SEX
AND
POWER

C000018683

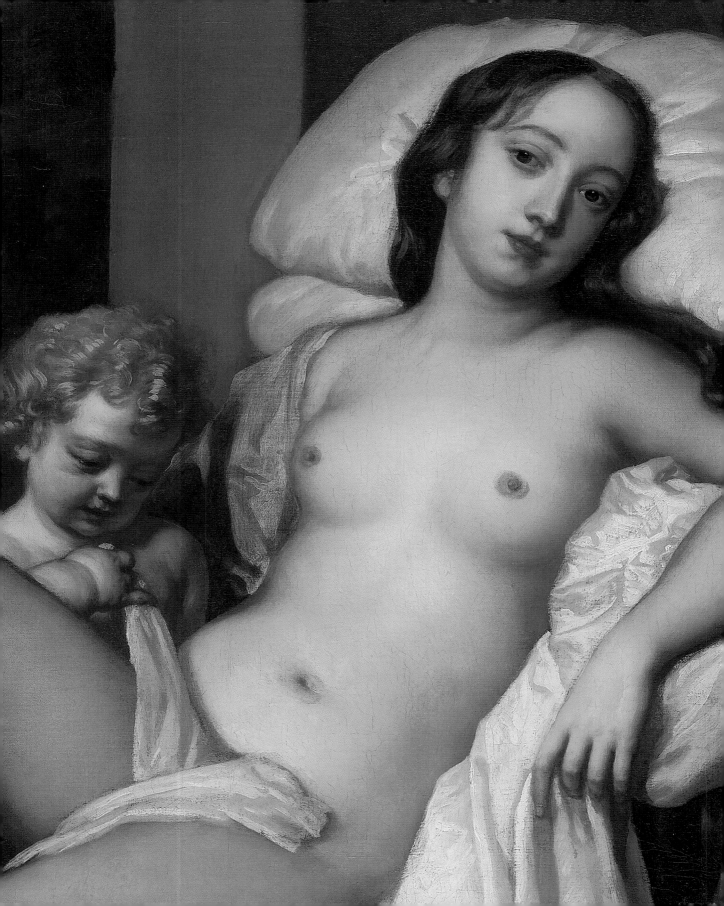

BEAUTY
SEX
AND
POWER

A Story of Debauchery and Decadent Art at the Late Stuart Court (1660–1714)

Brett Dolman

with
David Souden and Olivia Fryman

SCALA

**Historic
Royal Palaces**

Originally published to accompany *The Wild, the Beautiful and the Damned*, an exhibition at Hampton Court Palace in 2012, devised and curated by Brett Dolman, Collections Curator at Historic Royal Palaces

© Scala Publishers Ltd, 2012
Text © Historic Royal Palaces, 2012

First published in 2012 by
Historic Royal Palaces
www.hrp.org.uk

In association with
Scala Publishers Ltd
Northburgh House
10 Northburgh Street
London EC1V 0AT
www.scalapublishers.com

ISBN: 978 1 85759 756 1

Historic Royal Palaces Editor: Sarah Kilby
Picture Research: Annie Heron and Louise Nash
Project Manager and Copy Editor: Linda Schofield
Designer: Chrissie Charlton/Harrington & Squires
Printed and bound in Italy

10 9 8 7 6 5 4 3 2 1

All rights reserved. No part of this book may be reproduced, stored in a retrieval system or transmitted in any form or by any means electronic, mechanical, photocopying, recording or otherwise, without the written permission of Scala Publishers Ltd.

British Library Cataloguing in Publication Data.
A catalogue record for this book is available from the British Library.

Every effort has been made to acknowledge copyright of images where applicable. Any errors or omissions are unintentional and should be notified to the publisher, who will arrange for corrections to appear in any reprints.

page 1: Mary of Modena (Simon Verelst, *c* 1675–9)
page 2: Nell Gwyn, as Venus (Peter Lely, *c* 1668), detail
Inside front cover: The Mall, from St James's Park (Marco Ricci, 1668), detail

Picture credits

(b = bottom, t = top, l = left, m = middle, r = right)

Front cover illustration: Private Collection
Back cover illustration: The Pepys Library, Magdalene College, Cambridge
Inside front cover illustration: Image courtesy of the National Gallery of Art, Washington (Gift of Janet and David Bruce)

pp1, 8, 12, 14, 16, 22, 26, 27, 29l, 29r, 30, 31, 32, 34, 38, 39, 44, 47, 52–3, 60r, 63, 75, 76, 82r, 86, 87, 88, 90–1, 95, 99, 101, 103, 127: The Royal Collection © 2011 Her Majesty Queen Elizabeth II; pp2, 67: Private Collection; p10: © RMN (Château de Versailles)/Droits réservés; p11: By permission of the Trustees of the Goodwood Collection; pp13, 15, 25, 55, 59, 65, 73, 97r, 123, 124t, 124b: © National Portrait Gallery, London; pp18, 77, 78: © Historic Royal Palaces (p18 Photo Robin Forster); pp19, 102: Courtesy of the Museum of London; pp20–1: © Crown copyright: UK Government Art Collection; pp24, 43r: © National Maritime Museum, Greenwich, London; pp35, 109, 115, 116: © The Trustees of the British Museum; p36l: Beale Collection; p36r: Iris & B Gerald Cantor Center for Visual Arts at Stanford University, Committee for Art Acquisitions Fund; p41: By permission of The Trustees of Dulwich Picture Gallery; pp42, 61: The Collection at Althorp; p43l: Bridgeman Art Library (© Museums Sheffield), 51r, 56 (Yale Centre for British Art/Paul Mellon Centre/USA), 62 (Bibliotheque des Arts Decoratifs/Paris/ France/Archives Charmet), 68 (The Trustees of the Weston Park Foundation, UK), 71 (Private Collection/Photo Philip Mould Ltd, London), 113 (© Bristol City Museum and Art Gallery/UK); p45: By kind permission of Viscount De L'Isle from his private collection at Penshurst Place, Kent, England; pp49: National Trust Photo Library (Kingston Lacy, The Bankes Collection (National Trust), ©NTPL/Derrick E.Witty), 51l (Kingston Lacy, The Bankes Collection (National Trust), ©NTPL/John Hammond), 58 (Kedleston Hall, The Scarsdale Collection (acquired with the help of the National Heritage Memorial Fund and transferred to the National Trust in 1987) ©NTPL/John Hammond); 64 (Knole, The Sackville Collection (purchased by the National Trust with the aid of the National Heritage Memorial Fund), © NTPL/Jane Mucklow), 82l (Knole, The Sackville Collection (National Trust) © NTPL/John Hammond); pp60l, 94: Courtesy of Sotheby's Picture Library; pp80–1: Image courtesy of the National Gallery of Art, Washington (Gift of Janet and David Bruce); p85: © English Heritage Photo Library. From the private collection of Lord Braybrooke, on display at Audley End House, Essex; p89: © Victoria and Albert Museum, London; pp92: By permission of the British Library (G.520.1), 96 (C.112.f.9 (126), 97l (BL 1081.e.15), 118 (069261); p105: Permission by the Trustees of the Chevening Estate; p107: The Trustees of the 9th Duke of Buccleuch's Chattels Fund; pp111t, 111m, 111b, 114, 117: The Pepys Library, Magdalene College, Cambridge; p119: St Edmundsbury Heritage Service; p120: © Estate of James Abbe (Image supplied by Margaret Herrick Library, California); p125l: Courtesy of The Brudenell Collection; p125r: York Museums Trust (York Art Gallery). Purchased with the aid of a grant from The Art Fund, 1949.

Contents

Foreword

This book was written while we were preparing an exhibition on the same subject at Hampton Court, bringing together portraits of the mistresses of Charles II.

We wanted to reawaken interest in the baroque 'half' of the palace (not the Henry VIII bit!): the occasionally overlooked, but wonderfully elegant state apartments created for the Stuart kings and queens.

Hampton Court is in any case permanent home to two wonderful sets of late 17th-century paintings – the 'Windsor Beauties' of Sir Peter Lely, and the 'Hampton Court Beauties' of Sir Godfrey Kneller. Walking through the palace as curators, it's always fascinating to overhear how our visitors respond to these evocative but difficult portraits. 'Were they *all* royal mistresses?' 'Why is this one so *ugly*?' 'Why do they all look identical?'

These are interesting questions, and not easy to answer. It's partly to do with painting techniques, partly our expectation today that people will 'really' look like their portraits, and partly because notions of beauty change as the centuries pass.

Nonetheless, we felt that we ought to have a go. *The Wild, the Beautiful and the Damned* became an exhibition that took the paintings off the walls, gave them room to breathe, and to tell their own particular stories. The subject became a much wider exploration of 'beauty' at the end of the 17th century. What did it mean? What could you use it for? How was beauty pursued by artists, and how were Court beauties pursued by the infamously libidinous Charles II?

This period in history was a time when questions about people, paintings, beauty and sexual attractiveness came into sharp focus. With the upheaval of the Commonwealth finally over and with a Stuart king once again on the throne, women were taking centre-stage. They were increasingly visible both as sexual and political power players, with a confidence and verve that hadn't been seen before. However, their success challenged the social and sexual orthodoxies of a male world. Beauty became not just a political tool, but also a trap. In art, Lely created a model of idealised beauty in which women were both celebrated – and confined.

Was it empowering for Nell Gwyn to have Lely paint her lying naked in her bed, a celebration of her successful journey from orange-selling poverty to courtesan, or is this painting simply a dehumanised object of royal lust? We know that her lover, Charles II, kept his portrait of Nell displayed behind a painting of a landscape. He enjoyed swinging back the panel to reveal her to his friends, so that they could all enjoy looking together. But this king who consumed so many women, also took them relatively seriously as friends and advisors, as well as sexual playthings.

Of course our exhibition and this book are about history, but all of the questions we ask are just as relevant today. If while reading you forget who's who, do consult the Cast of Characters inside the back cover. The 'Beauties' are highlighted throughout with the symbol ★.

Lucy Worsley
Chief Curator, Historic Royal Palaces

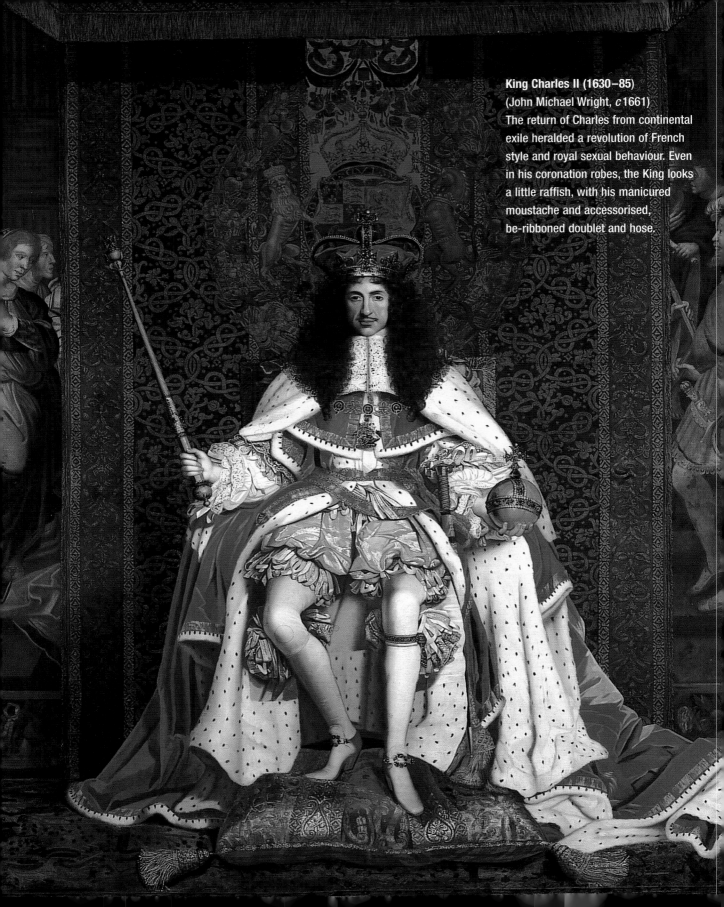

King Charles II (1630–85)
(John Michael Wright, *c*1661)
The return of Charles from continental exile heralded a revolution of French style and royal sexual behaviour. Even in his coronation robes, the King looks a little raffish, with his manicured moustache and accessorised, be-ribboned doublet and hose.

Better for us, perhaps, it might appear,
Were there all harmony, all virtue here;
That never air or ocean felt the wind;
That never passion discompos'd the mind:
But ALL subsists by elemental strife;
And passions are the elements of life.
(Alexander Pope, *An Essay on Man*, 1734)

Introduction

THE BEAUTIFUL REVOLUTION

It is 1660. The English Civil War is over, and the experiments of the Commonwealth and Cromwell's Protectorate have left England politically exhausted and confused; Charles II has been invited back from continental exile by the generals and grandees to rule over the still separate thrones of England and Scotland. He has brought with him a sense of European glamour or – if you are a frustrated republican – an intolerable French taste for baroque extravagance, financial corruption and loose women, but not necessarily in that order.

In particular, Charles has imported the French idea of a royal mistress, a concept that has become almost constitutionalised in Paris; not that English monarchs up to this point have all been scrupulously faithful, just that this sort of thing has always been a private affair with English kings, tolerated but separate from the public world of state politics and apparent matrimonial integrity. Charles II's reign is forever remembered as being the only occasion in English history when a monarch has explicitly

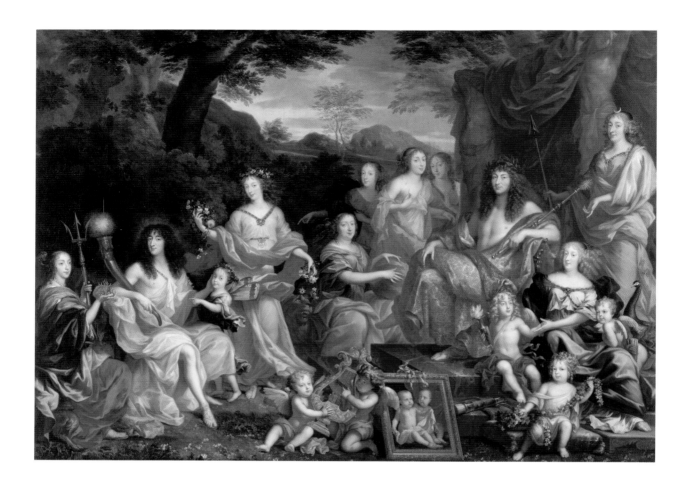

King Louis XIV (1638–1715)
and his family
(Jean Nocret, *c*1665–9)
Charles's youthful experience of the luxurious magnificence of the French Court of his cousin Louis had a lasting influence on his reign. Despite the vicissitudes of foreign policy and native mistrust of all things French, Charles remained a Francophile at heart.

flouted convention and paraded his mistresses before the Court, showering them with wealth and titles, and, even more controversially, allegedly allowing them influence in political debate.

The reputation of Charles II amongst historians is a mixed one. In general, most serious biographers have been critical of a king too easily swayed by his libido, too inconstant with his policies, too incompetent with his purse, and generally lucky to remain on the throne. Popular history, however, has fixed Charles's reputation as 'Old Rowley' (a contemporary nickname, borrowed from the name of one of Charles's own prolific stallions): a fun-loving monarch with the common touch, who liked to mix with his people (particularly if they happened to be young actresses) in the London streets and public theatres; a successful gambler who punctured the egos of the Court nobility by cleverly switching

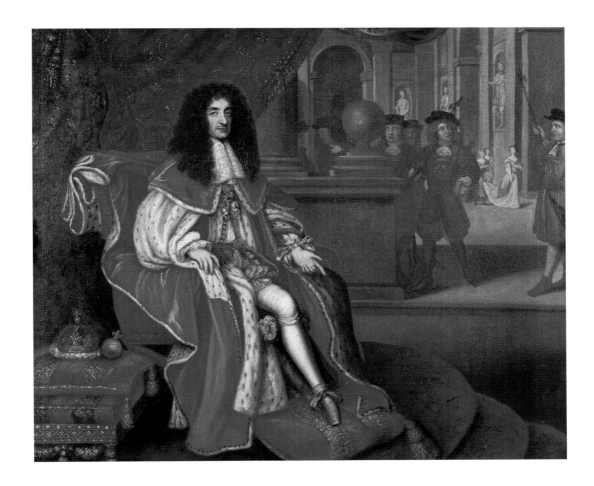

King Charles II and Louise de Kéroualle (1649–1734)
(Henri Gascar, c1672–80)
This is the only 'double portrait' of Charles and one of his mistresses to survive (Louise is shown in the background, with her attendants).
It reflects as bold a statement as would have been acceptable of Louise's enduring relationship with the King, commissioned, as it presumably was, by Louise herself.

policies, playing cliques and rapacious ministers off against each other, whilst seducing their wives.

The choice is yours. The truth is probably, as ever, somewhere in the middle. Charles was capable, clever, interested in sensible things like science and music, as well as art, theatre, drink and women (again, not necessarily in that order though). His political manoeuvres showed, at their best, a survivor's instinct and a persuasive charisma, but, at their worst, were racked by laziness, inconstancy and an unwillingness to trust anyone apart from himself.

Looking at it another way, the reign of Charles II was a period of revolutionary experimentation – in science, in art, and in sexual etiquette. The rulebook on how you were meant to behave at Court and, consequently, outside Court in the wider world (although this really only applied to the rich) was effectively torn

A formal garden; three ladies
surprised by a gentleman

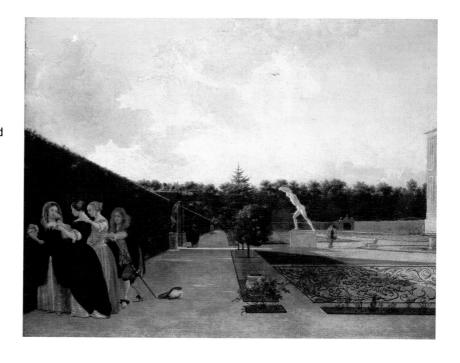

A formal garden; three ladies
surprised by a gentleman
(Ludolf de Jongh, 1676)
This scene from a garden of a Dutch
aristocrat encapsulates the continental
style as well as the suggestion of
gallant intrigue that Charles II imported
to England in 1660.

up in 1660 and rewritten. Women in particular sensed new possibilities and freedoms, although their very identity was, we must remember, still fundamentally defined as inferior to men. They appeared on stage for the first time, ran their own businesses, published plays and, in country houses and at Court, exercised control over household finances, matrimonial alliances and even political networks. Nell Gwyn crossed the social divide from the London brothels and public stage to the luxury of a house on Pall Mall. Partly this was an inevitable consequence of the Civil War, and the widespread slaughter of male heads of families and estates, but it was also the freedom offered by a licentious Court where 'beauty' – in particular – was eulogised and pursued, and where 'being beautiful' could get you what you wanted.

This book explores the multifarious meanings and ambivalent attitudes towards beauty in late 17th and early 18th-century England. This was an age of beautiful art – with palace ceilings and walls enveloped in acres of brightly coloured paintings revealing amorous gods and goddesses – of glamorous, enormously expensive parties, attended by Court beauties and foppish gallants, of elegance, magnificence and innovation. It was also an era of

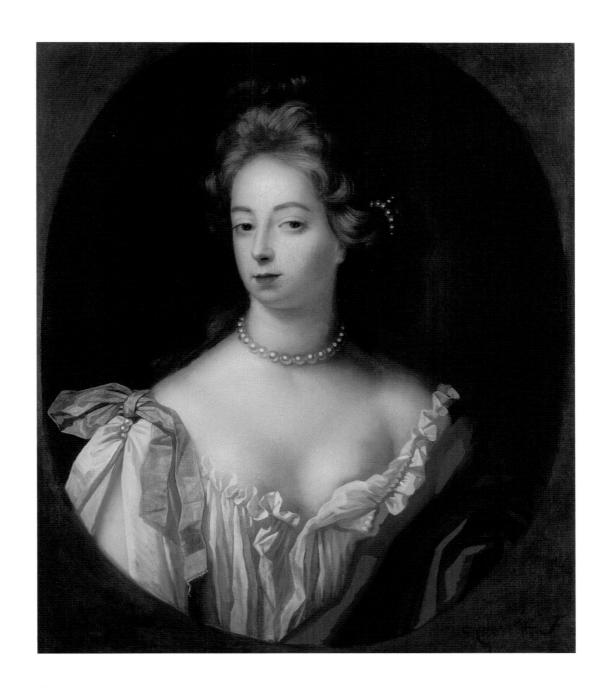

Nell Gwyn (*c*1651–87)
(Simon Verelst, *c*1683)
Charles II's mistress, 'pretty, witty Nell', wearing a string of pearls – perhaps identical to
the necklace Nell purchased in 1682 for £4,520 (about £340,000 today) and once owned by
Margaret Hughes, erstwhile mistress of Charles's cousin, Prince Rupert.

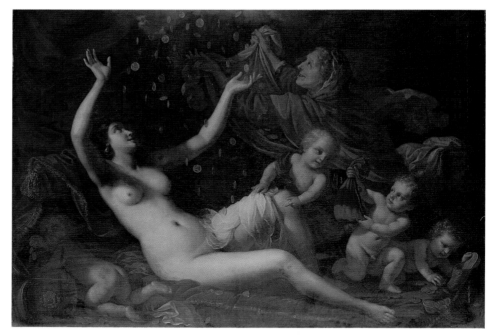

Danäe

(Benedetto Gennari, *c*1674) Charles II commissioned Gennari to paint a series of soft-core mythological beauties to hang in his private apartments at Whitehall Palace. Danäe was a princess, seduced by Zeus in one of his customary disguises – this time as a shower of golden rain, which Gennari has transformed into a waterfall of coins: an appropriate enough metaphor for the temptations, and rewards, of royal sex.

opposite:

Barbara Villiers (*c*1640–1709) (John Michael Wright, 1670/76) Portraits of women in picturesque 'Arcadian' landscapes, or as shepherdesses, were meant to evoke a 'Golden Age' of bucolic simplicity and Christian innocence. This was in stark contrast to the decadent materialism of the Restoration Court.

artistic titillation – of revealed flesh and erotic invitation, of drunken, wasteful debauches, illicit trysts, adultery and deceit, of decadence, venality and promiscuity.

Beauty was both an aesthetic ideal – an experience of something pure, spiritual and true – and an earthy physical reality – a sexually charged elemental seductive force. Beautiful women were praised and revered, but also pursued and possessed; their portraiture champions their virtue whilst advertising their availability – goddesses and lovers at the same time. As Samuel Pepys wrote of Charles II's mistress Barbara Villiers, 'For her beauty I am willing to construe all this to the best and to pity her wherein it is to her hurt, though I know well enough she is a whore.' Men, meanwhile, were heroic warriors and dandified libertines, politicians, poets and duellists. Living the beautiful life meant embracing this revolutionary reaction against the artistic and cultural sterility of the Commonwealth, and absorbing the manifold sexual and material rewards of a dissolute indulgent Court.

The death of Charles in 1685 catalysed the slow extinction of this embryonic sexual revolution. His brother James II lasted only three years. Matching a similar thirst for infidelity but with less

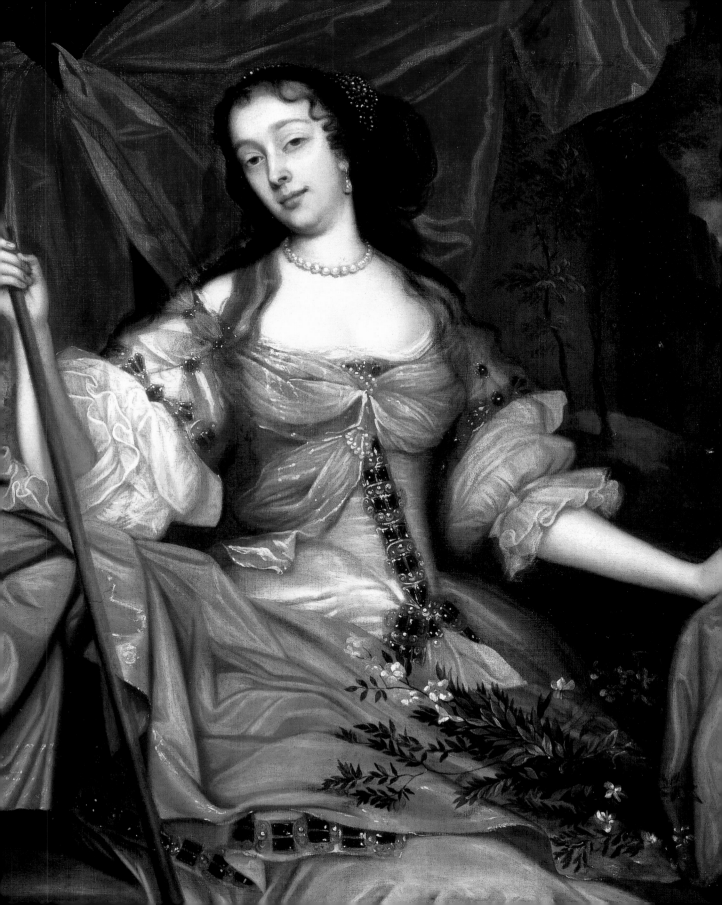

James, Duke of York (1633–1701) and his family

(Peter Lely and Benedetto Gennari, *c*1671–80)
The brother of the King, and the heir to the throne, was similarly liberal with his sexual favours. His mistresses had their alluring portraits painted in the same studios as more conventional family commissions.

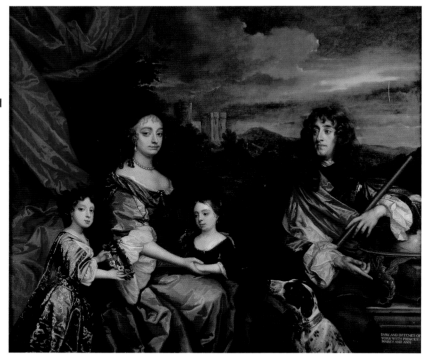

charisma, he was guilty not just of being decadent, but of being decadent *without style*. Where Charles had been suave and tolerant, encouraging flirtations and libidinousness, James was awkward and hypocritical, promoting a more regal and correct Court whilst indulging his own mistress. More significantly, James made the critical mistake of being publicly Catholic, something the country was not yet ready to accept – not after the infamous brutality of Mary I, and the subsequent slow emergence of an English national personality built around a fear of continental despotism and Catholicism (the two, it was believed, went hand-in-hand).

Stubborn, vain, and financially dependent on a parliament that remained committedly Anglican, James II fled the country when his nephew (and son-in-law) William, Prince of Orange and Stadtholder of the Netherlands, invaded in 1688. This 'Glorious Revolution' confirmed England's (and eventually Britain's) Protestantism and redefined monarchical authority, bolting the very existence and identity of monarchy to an empowered governmental executive. Although it was not inevitable at the time, this would finally kill the ancient royal belief in the divine

right of kingship, and in its place establish the constitutionally dependent monarchy that survives today. James II could have made a comeback, but he was bedevilled by poor advice and what he perceived as the treachery of his closest supporters, including that of his two daughters, Mary and Anne, who were avowedly Anglican. Mary II, James's eldest daughter, ruled, with her cousin and husband William III, from 1688 until her early death from smallpox in 1694, whilst Anne acceded to the throne after William's death in 1702. Despite growing up amidst the debauchery and dissipation of their father's and their uncle's Court, neither Mary nor Anne is remembered for a similar thirst for excess and wantonness. Instead, restricted by a stronger parliament and consequently by a lack of ready cash, the Court realigned itself along more traditional and uncontroversial standards of behaviour. It was still grand and baroque, but a little less hedonistic; 'profane wit' and depraved conduct were out of fashion. In fact, the chief protagonists of the 1660s and 1670s, the libidinous rakehells like John Wilmot, Earl of Rochester, and the upstart mistresses like Nell Gwyn, were all dead or older and a little wiser by the early 1700s. Barbara Villiers, the most notorious of all, survived into her 60s, still scheming, spending and sexually inexhaustible.

It is tempting to draw a neat line in about 1700 and conclude that the party had finally come to an end – Britain could now get on with the serious business of trade and empire. The new sober national ambition was expressed through the Act of Union of 1707, which brought England and Scotland together, and the martial victories in the great wars of the early 1700s that started bringing serious money back into the exchequer and the pockets of the nobility. This is a little simplistic, and we can only really say this because we know what happened next, but the initial revolutionary impetus of the 1660s had definitely waned, and with the death of Queen Anne in 1714, the Stuart dynasty was also extinguished. Their Hanoverian cousins brought a different set of customs and flavour to an increasingly constitutional form of political and Court life. There were still mistresses to be taken and politicians to bribe, but not quite with the same panache as the Stuarts had endeavoured to command.

Mary and her sister Anne were, indisputably, queens, but they were also, inescapably, women. Despite the power and the new spirit of freedom and influence enjoyed by many high-born women in the late 17th century, their official position was still

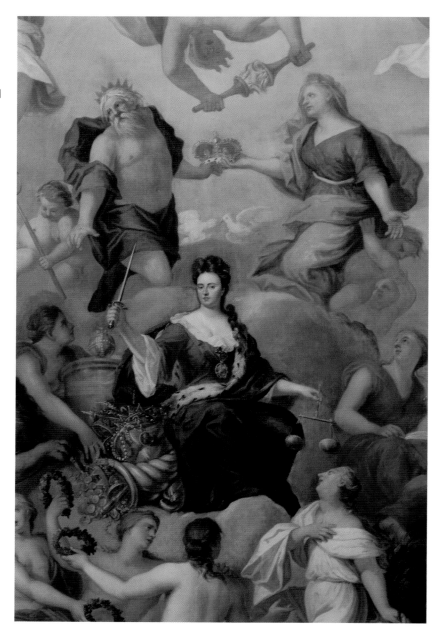

The Apotheosis of Queen Anne
(1665–1714)

(Antonio Verrio, 1703–5)
The Queen's Drawing Room at Hampton Court Palace is decorated with triumphal royal baroque propaganda. Queen Anne, clothed in imperial purple, is crowned by Neptune and Britannia, declaring her dominion over sea and earth.

weak; Anne was certainly not free to act (even if she had been tempted so to do) in the same inconstant and dissolute way as her uncle. In a way that could not easily be defined, every woman – even a queen – was still inferior to every man. There was, as ever, a culture of double standards. Men were 'gallants' if they

A woman at her toilette

(Fashion plate, 1694)

Much of the evidence for the styles and accessories of 17th-century beauty practice comes from fashion plates, which helped to publicise the latest trends in aristocratic chic.

seduced their way into a lady's affections; women were sexual predators and whores – leaky vessels created to conceive children and prone to hysterical (from the Greek *hustera*, meaning 'womb') inconsistency.

Female beauty itself, praised by poets and idealised by artists, was at the same time still envied and feared. As Harriet, the heroine of George Etherege's 1676 play, *The Man of Mode*, admits, 'Beauty runs as great a risk exposed at court as wit does on the stage, where the ugly and foolish all are free to censure.' Just as women were considered deceitful and dangerous, so was their artful use of cosmetics criticised and condemned. Men were jealous of female beauty and suspicious of the deceptions of beauty products, but they still, nonetheless, expected their wives and their lovers to be beautiful. And being beautiful was, of course, a full-time commitment. Women (and men) despaired in front of their dressing room mirrors, surrounded by potions and pastes, perfumes and patches, as they battled to keep infection, disease or the ravages of age at bay, while the very ingredients employed to assist them were often poisonous, sometimes fatal. Beauty could thus be a curse as well as a blessing – something that could lead to jealousy, slander, loss of honour, and even death.

Appreciating the equivocal nature of beauty helps us to understand the lives of some of the most charismatic and controversial men and women in British history – those Restoration mistresses and degenerate libertines who lived, loved and died amidst the bespangled luxury of the late Stuart Court, and who are the main subjects of this book. Their understanding and use of beauty was reflected in their portraiture and art, and women in particular learned how to use the power of an evocative, sexy image to advertise their beauty and, sometimes disingenuously, their virtue.

This book is principally, however, about the nature of beauty itself: its ambiguity, its authority and its transience. This is a story about how beauty is pursued, possessed and lost, not just by the heroes and anti-heroes of the late 17th century, but by all cultures and all periods. This is a timeless tale about our continuing obsession with beauty and the impossible dream of capturing it, owning it and harnessing its power forever.

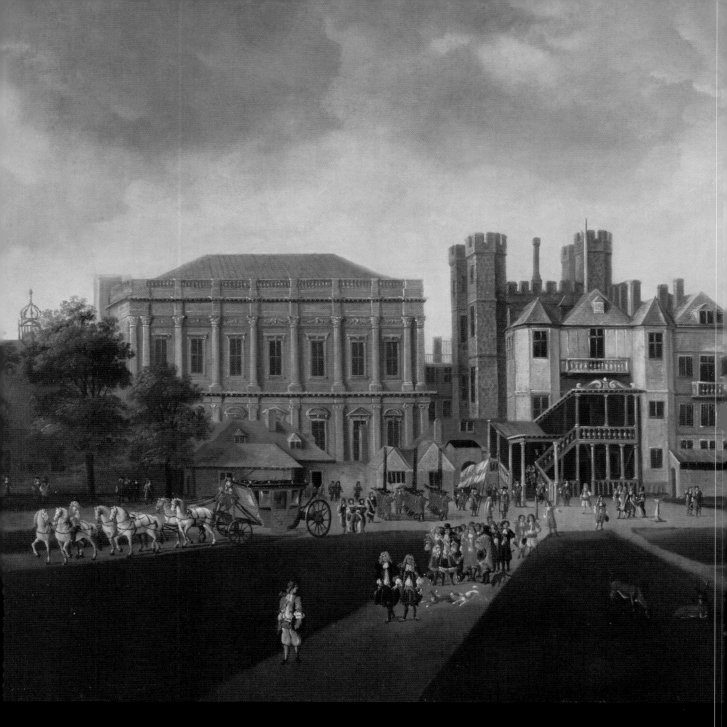

Whitehall Palace
(Hendrick Danckerts, c1675)
The old headquarters of the Stuart Court in central London was not only the home
and workplace for the hundreds of people that served in the Royal Household, but
it was also, still, the centre of political power and fashionable social life.

Barbara Villiers, as Minerva★
(Peter Lely, *c*1663–5)
The 17th century saw the emergence of
connoisseurial galleries of beautifully
painted collections by the best artists.
The selection of portraits reflected the
collector's political and social interests,
as well as the noted beauty of the
sitters themselves.

Chapter 1

So Cleveland shone in warlike pride
By Lely's pencil deified:
So Grafton, matchless dame, commands,
The fairest work of Kneller's hands:
(Horace Walpole, *The Beauties*, 1746)

BEAUTY AND THE PURSUIT OF PERFECTION

'Beauty' was, throughout this period, synonymous with 'Virtue': beauty of the flesh indicated an inner beauty, a virtuous soul. This meant that beauty was celebrated for its divine purity, and to possess beauty was to own a little bit of paradise. In portraiture, this is why men appear as brave soldiers and women as classical goddesses.

Artists like Henri Gascar, Benedetto Gennari, Jacob Huysmans, Peter Lely and Simon Verelst developed competing portrait styles that sought not only to record the likenesses of their subjects, but also to capture the essence of their beauty. Nell Gwyn was painted by Verelst as Diana; King Charles's wife, Queen Catherine of Braganza, by Huysmans as St Catherine; whilst Lely immortalised King Charles's naval officers from the battles of Lowestoft and Sole Bay with a lofty grandeur that sought to idealise the 'beauty' of virtuous military action. Later in the century, Godfrey Kneller developed a more refined, 'nobler'

Frescheville Holles (1642–72) and Robert Holmes (c1622–92)

(Peter Lely, c1672)

Even though notions of male beauty were shaped on the battlefield rather than at the dressing table, Lely has still contrived to idealise his sitters. Holles had lost his left arm in combat, but this is artfully concealed, whilst the two heroes are robed in Turkish dress, with Holles carrying an oriental sword, alluding to their role in the successful attack on a Dutch convoy returning from Smyrna in 1672.

statement of beauty for men and women that would influence later 18th-century portraitists like Joshua Reynolds and Thomas Gainsborough.

Most famously of all, Lely immortalised some of the most important female courtiers of the day in a series of portraits now known as the 'Windsor Beauties'; this is the kind of painting that he was famous for *then*, and remains best known for today. The term is an elastic one, as the 'Windsor Beauties' have changed over time, displayed, grouped and confused with other portraits by Lely, and paintings by other artists. The Windsor epithet was coined to describe a set of Lely's portraits that hung at Windsor Castle in 1688, and today it defines a set of ten portraits usually exhibited at Hampton Court in the Communication Gallery, together with the assumed patroness of Lely's commission, Anne, Duchess of York. These ten paintings, together with a now lost eleventh portrait, probably of Anne's sister, Lady Frances Hyde, would seem to be identical to an 'original' collection, assembled by the

Sir Peter Lely (1618–80)

(Self-portrait, *c*1660)
Lely, a Dutch artist, came from a wealthy and respected background. He moved easily into the gap left by the death of Anthony van Dyck in 1641 to become the in-demand portraitist for anyone with stylistic pretensions at Court.

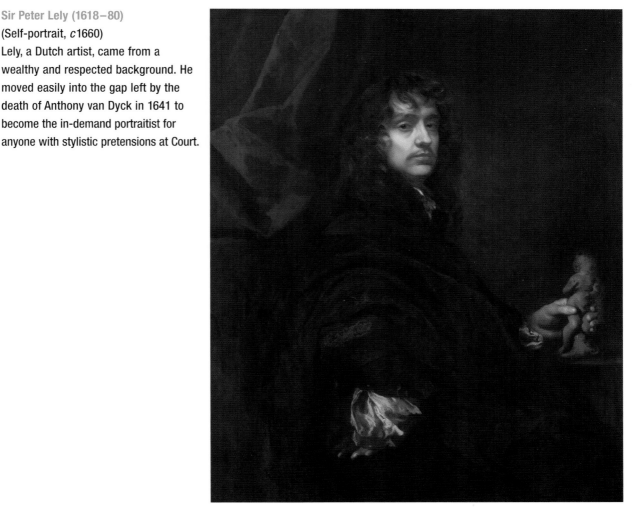

Duchess, possibly at St James's Palace and listed in the Duke's inventory of 1674. They were all painted in the early and middle years of the 1660s, commissioned or acquired over time as a gallery of the most ornamental of the principal friends, allies and confidantes of the Duke (later James II) and Duchess of York. Lely was not simply creating a pictorial address book of the Yorks' household circle. Anthony van Dyck, the Court painter to Charles I, had already established an approved canon of Court portrait poses and identities, compositions that extolled the virtues of their subjects with artistic flair and exacting detail.

Pallas Athena

(Parmigianino, *c*1531–8)
Lely was happy to distort the strict rules of classical proportion to achieve a more graceful, sensual line in his portraits. Italian artists like Parmigianino had done this before (Athena's neck has been purposefully stretched).

Lely was very much van Dyck's successor (and was keen to show that he was), but he also took his inspiration from the Mannerist painters of the late Italian Renaissance. Artists like Parmigianino explicitly flouted the classical rulebooks on perspective and proportion, better to emphasise the tactile curve of a breast, the suggestive tilt of a head, or the almost imperceptible beginnings of a smile. Lely took van Dyck's style, mixed in some Italian virtuosity

Venus (1st or 2nd century AD)
Lely's considerable success enabled him to build up a substantial collection of 'Old Master' paintings and antique works of art. This particular Roman copy of an earlier Hellenistic-period bronze statue from ancient Greece was a sculpture that Lely owned and used in his studio.

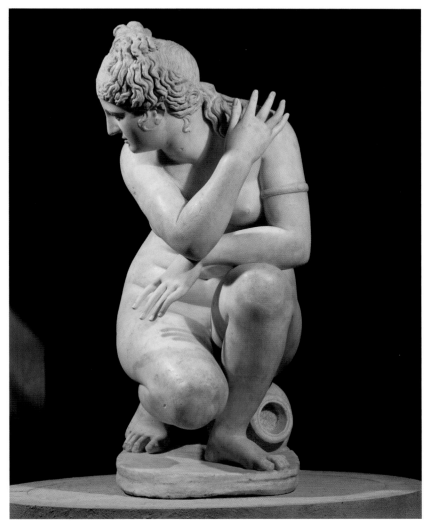

and adventure, and added his (and his generation's) more avowedly sensual sympathies to create languorous evocations of beauty. These pictures are more than just portraits: they are idealisations of what beauty meant in the 1660s.

Lely's approach meant explicitly 'improving' on nature. As the artist and art theorist Jonathan Richardson would advise a generation later in his *Discourse on the Dignity, Certainty, Pleasure and Advantage of the Science of the Connoisseur* of 1719:

The business of painting is not only to represent Nature, but to make the best choice of it; nay to raise, and improve it from

what is commonly, or even rarely seen, to what never was, or will be in fact, tho' we may easily conceive it might be. As in a good portrait, from whence we conceive a better opinion of the beauty, good sense, breeding, and other good qualities of the person than from seeing themselves, and yet without being able to say in what particular 'tis unlike: for nature must be ever in view.

The portrait became something much more than a statement of likeness. It was now an expression of virtue, and an artist was expected to present a portrait that was an expression of the model's *grace*, the highest form of beauty.

There is, of course, an inherent problem in this method. Idealisations tend, naturally, towards the subjective and repetitive (and also depend on the subject possessing enough raw material to begin with). Lely was not always successful in capturing an accurate representation of his sitter and his paintings were criticised at the time for being 'good but not like'. Today, framed within, and dominated by, the alien style and dress codes of the 17th century, they can appear too much alike, governed (it has often been argued) by Lely's own personal concept of beauty, the 'languishing air, long eyes, and drowsy sweetness', inspired by his chief muse, Barbara Villiers.

With success, demands on Lely's time increased, as every courtier coveted the latest fashionable artistic accessory. Sitters were booked in at hourly intervals, where a quick chalk sketch would be completed; later, more detailed sittings might last for three hours, but early on in his career, Lely established a studio, with assistants and a numbered list of portrait templates from which his clients could choose a pose, costume or background. Combined with standard-sized canvases, this meant Lely could more easily transfer a favoured pose from one portrait to another and, at its most extreme, that only a portrait face needed to be added before the rest of the piece was completed by a studio assistant. This reduced the time required for personalised sittings, when only the most exacting client (who could afford more of Lely's time) would demand his full attention to every detail. In fact, 'sitting for a portrait' was more of a statement of status (and wealth) on the part of the sitter, than it was a route towards artistic superiority; Lely himself was happy not to work from life.

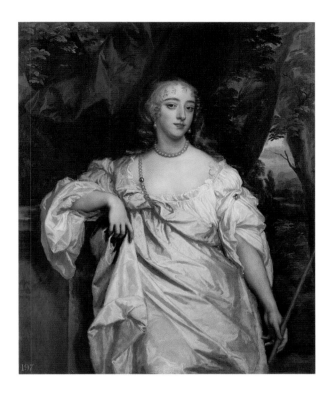

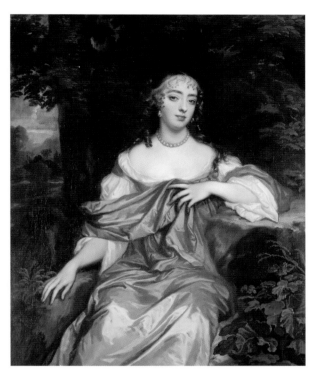

Mary Bagot (*c*1645–79)★
(Peter Lely, *c*1664–5)

Frances Brooke (*c*1644–90)★
(Peter Lely, *c*1665)

Lely's idealising style encouraged sitters to think of themselves as fashion plates, as well as making it easier for the artist, and his assistants, to reproduce portraits quickly. The similarity between these representations has led to confusion even over their identity. The portrait on the left may be Margaret Brooke, Frances's sister.

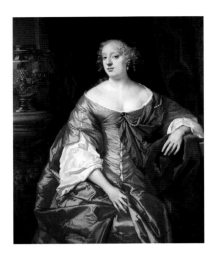

Anne Digby (c1646–1715) ★
(Studio of Lely, c1666)
Some of Lely's Beauties were not, at the time, famed for their beauty at all. Other notable beauties were left out of the collection because they did not have a direct link with the Duke and Duchess of York. Anne, the daughter of an Earl, became Countess of Sunderland in 1665 and had a conventional marriage and career: she was Lady of the Bedchamber to Queen Catherine and survived into her 60s, managing her husband's estate at Althorp.

Whole portraits were sometimes copied by Lely's studio, to meet the demand for duplicate portraits, and the final quality could, and did, vary as a result. Even within such a high-profile series as the 'Windsor Beauties', repetition of pose and facial proportions is clearly evident. In the case of Lely's portrait of Anne Digby, it seems highly probable that this particular copy of a much better version at Althorp is not in Lely's hand at all: it is arguably the least beautiful portrait in the set, and does not compare well to descriptions or other portraits of Anne. For some commissions, the originality, beauty or even accuracy of the portrait, was less important than the requirement to provide a mechanically produced duplicate of an existing portrait of a particular sitter. Portraits displayed on the wall were often, still, declarations of family connections or political loyalty, rather than statements of cultural sophistication.

Lely at his best, however, was unrivalled in the 1660s for the quality and depth of his work – for his handling of colour and texture, for his draughtsmanship and for his ability to capture likeness, whilst also creating beauty on canvas. Of the 'Windsor Beauties', Elizabeth Hamilton is, many have argued, the finest in quality, and perhaps also where Lely's quest for beauty has been most successfully realised. This is both a very individual portrait and something else entirely different. Elizabeth is portrayed here as St Catherine of Alexandria, with her martyr's palm and wheel (the iconographic shorthand for the device on which Catherine was tortured). This is a common subject, particularly appropriate for brides-to-be, as the artist – and consequently the sitter – are effectively saying that Elizabeth embodies not only exterior beauty, but also the internal virtue of St Catherine, who serves as a model for piety and chastity, as well as being one of two saints who experienced a mystical 'marriage with Christ'. Elizabeth, captured here by Lely, probably on the occasion of her marriage at the age of 22, is therefore the ideal woman and the perfect wife.

Elizabeth came from an aristocratic family, like most of the 'Windsor Beauties', and was eulogised as 'La Belle Hamilton', portrayed (admittedly by her brother Anthony, within the *Memoirs* of Elizabeth's husband, the Count of Grammont) as of unrivalled beauty and intelligence. His description encapsulates how feminine beauty was defined at the Restoration Court:

Queen Catherine of Braganza (1638–1705), as St Catherine of Alexandria

(Jacob Huysmans, *c*1664)

The virgin martyr was a popular figure in art – not least because she shared her name with Charles II's queen. The presence of her instrument of torture in such portraits reminded everyone of the Saint's readiness to endure pain, something the Queen was, perhaps, also keen on making clear through this choice of image.

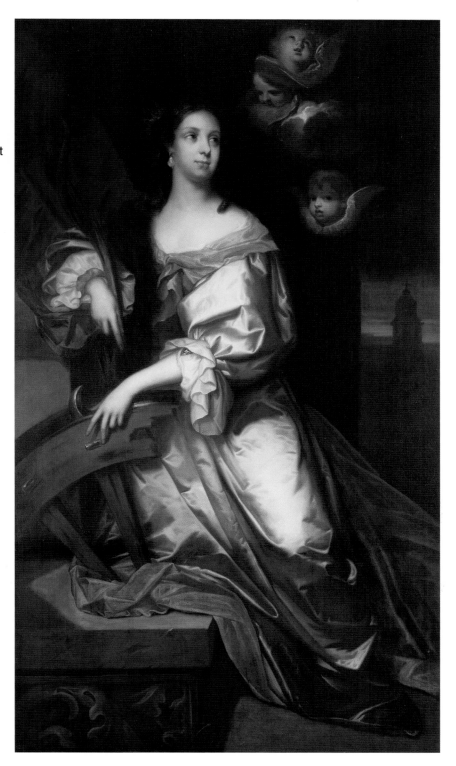

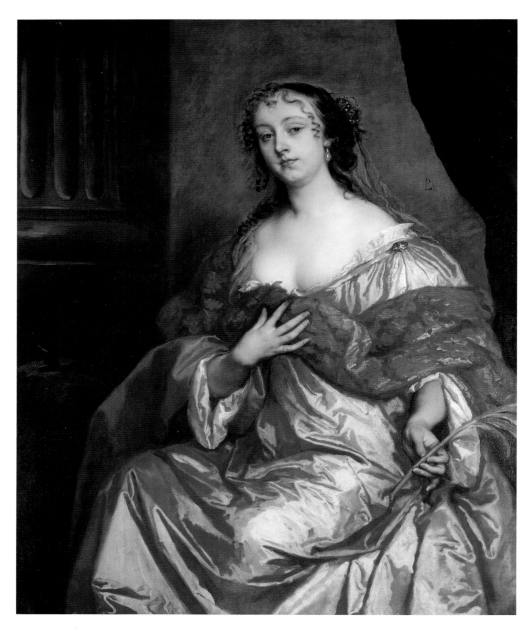

Elizabeth Hamilton (1641–1708) ★
(Peter Lely, c1663)
Elizabeth's beauty and modesty attracted the Count of
Grammont, who gave up his lustful pursuit of a number of
other Court beauties and proposed marriage; Elizabeth and
her husband subsequently spent an extremely luxurious
life at the French Court.

'Beauty is heaven's most bounteous
gift esteem'd,
Because by love men are from vice
redeem'd.'
(John Sheffield, Duke of Buckingham,
*To one who accused him of being
too sensual in his love*, c1720)

She had the finest shape, the loveliest neck, and most beautiful arms in the world; she was majestic and graceful in all her movements; and she was the original after which all the ladies copied in their taste and air of dress ... Her forehead was open, white, and smooth; her hair was well set, and fell with ease into that natural order which it is so difficult to imitate. Her complexion was possessed of a certain freshness, not to be equalled in borrowed colours; her eyes were not large, but they were lively, and capable of expressing whatever she pleased; her mouth was full of graces, and her contour uncommonly perfect; nor was her nose, which was small, delicate and turned up, the least ornament of so lovely a face ... Her mind was a proper companion for such a form: she did not endeavour to shine in conversation by those sprightly sallies which only puzzle, and with still greater care she avoided that affected solemnity in her discourse, which produces stupidity; but without any eagerness to talk, she just said what she ought and no more ...

Beauty meant not just a pretty face but also a correctly proportioned one, as well as an elegance of movement, a naturalness and variety of expression, a perfect dress sense and a modesty becoming her status as a woman (she didn't talk too much). Lely's challenge in portraiture was to display these qualities on a two-dimensional canvas. He did this by pose, posture – particularly the disposition of the hands, suggesting grace or elegance – expensively arranged drapery, and a suggestion of seductive sex appeal with the exposed chest and shoulder.

Courtiers like Elizabeth were happy to promote this virtuous image of themselves in art, as part of a campaign of self-promotion that alluded to, and (in some cases) reinforced, the idea that they were paragons of courtly Christian virtue in the flesh as well. A woman was still defined, at this point, by her looks and by her matrimonial career, and her embodiment of the correct vocabulary of appropriate female assets. A Lely portrait was testament to, and an advertisement for, a woman's beauty and virtue.

Lely similarly depicted Frances Stuart as the *chaste* virgin huntress, the goddess Diana. Frances was actively *chased* around the palace by Charles II soon after her arrival as a teenage Maid of Honour to Queen Catherine in 1662. Pepys also fancied himself 'sporting with her with great pleasure'. She resisted and,

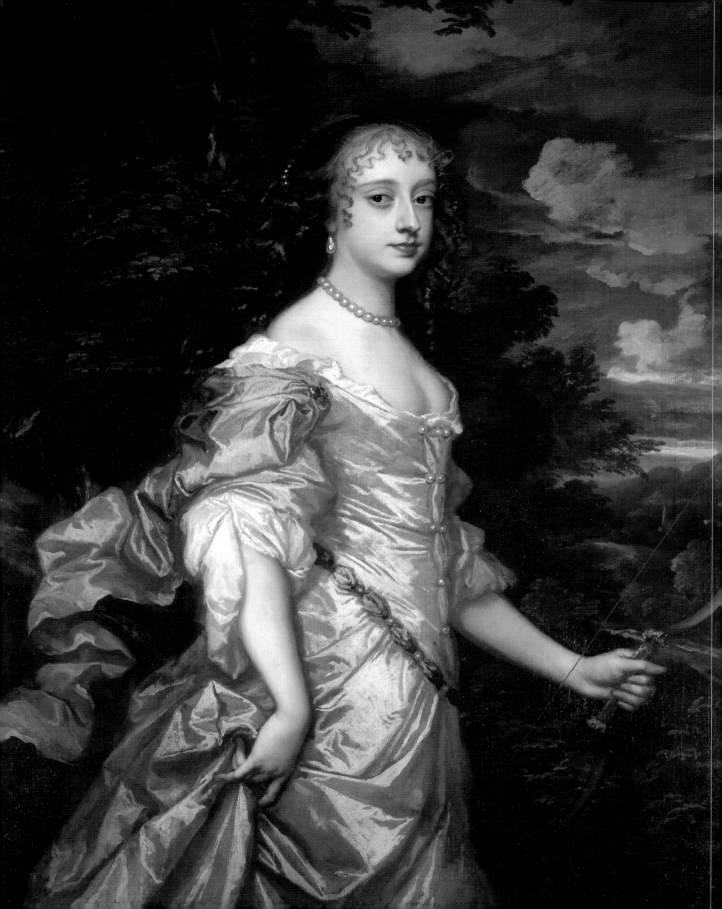

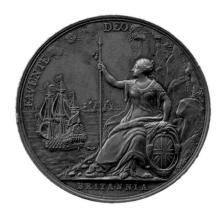

'Peace of Breda',
commemorative medal

(Jan Roettier, *c*1667)
Pepys visited Roettier's studio in 1667, remarking on 'the King's new medal, where in little there is Mistress Stuart's face, as well done as ever I saw anything in my whole life ... and a pretty thing it is that he should choose her face to represent Britannia by'. A profile of Charles II appeared on the other side: power, virtue and beauty combined.

Frances Stuart (1647–1702) ★

(Peter Lely, *c*1662)
Pepys described Frances as 'The prettiest girl in the world, and the best fitted of any to adorn a Court' with 'her sweet eye, little Roman nose and excellent *taille*'.

as such, became famous at the time not just for her beauty (the only 'blazing star' at Court, according to her contemporary Elizabeth Frazier) but also for her virtue. By her own later admission (as recorded by John Evelyn in his diary) this had not been easy: 'She could no longer continue at the Court without prostituting herself to the King whom she had so long kept off, though he had liberty more than any other had, or he ought to have, as to dalliance.'

Frances also sat as a model for Jan Roettier, the engraver, and became immortalised as Britannia on the commemorative medals of 1667, issued to celebrate the naval victories of that year. Her presence echoes Edmund Waller's satirical poem, *Upon the Golden Medal*:

> Britannia there the fort in vain
> Had battered been with golden rain
> Thunder itself had failed to pass
> Virtue's a stronger guard than brass

Britain's virtue should protect her against foreign invasion, we are told, just as Frances's virtue protected her against the King.

Evelyn was particularly keen on extolling the virtues of his favourite female courtiers (as opposed to his fellow diarist, Pepys, who was much happier praising their beauty). Margaret Blagge, Maid of Honour to the Duchess of York, became, for Evelyn, not only an intimate friend but also a symbol of feminine perfection; their surviving letters are testaments to the dissolute distractions of the Court, and their determination to resist temptation and sin, and pursue a perfect friendship and a virtuous life. Indeed, a true and pure friendship, stripped of all carnal desires, could be, argued Evelyn, a path towards an understanding of divine love: 'Love, that celestial gift, which rests in the soul, and tends to heaven from whence it came, languishes and dies under the feet of a terrestrial beauty, and often ends in fear and despair, in rage and folly ... but friendship is freed of all this.' Evelyn's 'Seraphic Love' dispensed with the messy business of sex, and replaced it with a pure Platonic reflection of the mystic union with God, borne from virtuous study and spiritual devotion.

Yet Margaret was also a very marriageable young woman. Her letters to Evelyn show the limitations and lack of alternative career paths for a *virtuous* Court beauty. With the 16th-century

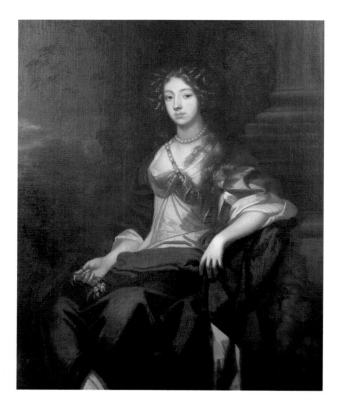

Margaret Blagge (1652–78)
(Unknown artist, *c*1670)

Margaret Blagge
(Matthew Dixon, 1673)

'Beauty is a blessing, and a great jewel, and you may glorify God by it,' John Evelyn assured Margaret. He may also have been assuring himself that his own adoration of a much younger woman was truly 'Seraphic' and not, just a little, worldly.

destruction of convents (which had at least offered a support-structure and sanctuary for women keener on worshipping God than their husband), there was no real identity or future, yet, for a genteel woman outside the world of matrimony. In the final reckoning, Margaret chose marriage, to Sidney Godolphin, who would much later become chief minister to Queen Anne; the couple married in secret, without telling Evelyn or the Court. Three years later, Margaret died in childbirth aged just 26.

Margaret's portraiture is particularly interesting as it reflects her internal battle between her devotional and temporal ambitions. One of the portraits to survive, in the style of Lely, is a fairly typical example of an official beauty portrait, with the languid pose, informal loose, provocative clothing, direct gaze and the figure of Cupid carved on the nearby plinth, holding out the promise of

love and availability. A second painting, commissioned from Matthew Dixon by Evelyn, shows a rare modesty and piety for this sort of portrait. Margaret's pose is demure, seated on a tombstone, with eyes downcast in thought; the painting's subject and its very commission are a reminder of their friendship and their quest for a heavenly love beyond the debauched material world of the Court. Nonetheless, the painting cannot quite escape its Restoration context: Margaret's shoulders, neck and arms are sensually revealed. This is not the buttoned-up portrait of a religious zealot.

Most of the artists in the late 17th century, like Dixon, followed Lely's example, and tried to marry virtuous and sensual concepts of beauty in the same portrait. By the 1690s, this approach was both extended and rejected by Lely's successor as principal Court artist, Godfrey Kneller. The 'Hampton Court Beauties' were commissioned by Queen Mary II perhaps in emulation of her mother's earlier collection. These were intended for her newly built riverside Water Gallery: 'the most beautiful site', we are told by Daniel Defoe, 'because the originals were all in being, and often to be compared with their pictures'. With these eight portraits, Kneller is following, more assiduously than Lely, the guidelines detailed in contemporary works on art theory. Books like Roger de Piles's *The Art of Painting* stressed the need for the painter to go beyond the mere 'face painting' of a likeness, but also to add nobility, grandeur and grace to a portrait, because beauty by itself was not enough. 'Grace and Beauty are two different things, Beauty pleases by the Rules only, and Grace without them. What is Beautiful, is not always Graceful; but Grace join'd with Beauty is the height of Perfection.'

For Lely, 'grace' seems to have meant sex appeal or Mannerist stylistic tweaks to the proportions of a face, or the disposition of a pose, to make it more enticing: the 'je ne sais quoi' behind the rules of attraction that also echoed the inner and real beauties of his subjects, which were similarly divinely ineffable and not easily codified by draughtsmanship. Kneller, on the other hand, fixed on a stricter neo-Platonic form of portraiture, where inner beauty and virtue are more tangibly represented by details in the painting, rather than the erotic undertones of partly revealed flesh: a dolphin as an emblem of love; a rose for beauty; a lizard for death; a distant ship for hope. Kneller's women also stand upright, refined and aristocratic – they are full-length, vertical compositions – and are

Isabella Bennet (1667–1723) ★

(Godfrey Kneller, *c*1690)

Kneller's Duchess of Grafton holds a shell under a fountain of Cupid whilst turning back towards a flowerpot showing some lecherous satyrs abducting a nymph. This equivocal message suggests that earthly love was perhaps a route towards an understanding of divine love. Isabella may even be personifying Venus herself, and the portrait's message may be that 'beauty' is borne from balancing the three Platonic principles of a virtuous life: activity, contemplation and pleasure.

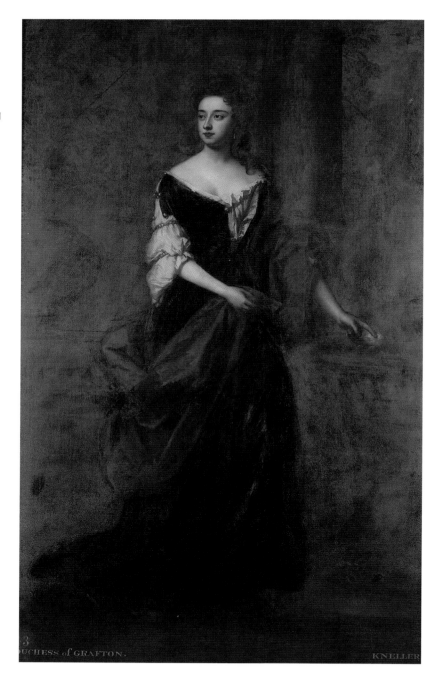

(Peter Lely, *c*1665)
Lely (as well as Kneller) made free use of symbolism in his portraiture. Here, a rose stands for beauty, as well as the brevity of life. Such imagery, however, was frequently transferred from other portraits, and became simply a fashionable artistic accessory.

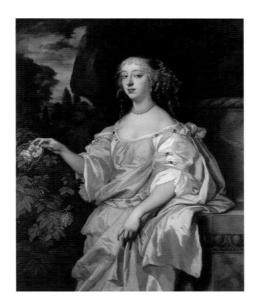

active and graceful, perhaps caught in the act of entering a room, rather than lazily draped across a chair; women who are sensitive rather than sensual. As the poet and dramatist John Dryden wrote in 1694, 'Though Nature, there her true resemblance bears, A nobler Beauty in thy piece appears.'

The artist of the late 17th century was engaged on a difficult quest. If he was commissioned to provide a portrait of a beautiful woman, he was expected to deliver more than just a likeness; the artist had to seek to represent beauty itself, and final judgment depended on his ability to capture perfection.

> But earth-born graces sparingly impart
> The symmetry supreme of perfect art;
> For tho' our casual glance may sometimes meet
> With charms that strike the soul, and seem complete,
> Yet if those charms too closely we define,
> Content to copy nature line for line,
> Our end is lost. Not such the Master's care,
> Curious he culls the perfect from the fair;
> Judge of his art, thro' beauty's realm he flies,
> Selects, combines, improves, diversifies;
> With nimble step pursues the fleeting throng,
> And clasps each Venus as she glides along.
> (Charles du Fresnoy, *De Arte Graphica*, English translation, 1695)

In days of Ease, when now the weary sword
Was sheath'd, and Luxury with Charles restor'd ...
Lely on animated canvas stole
The sleepy Eye, that spoke the melting soul.
No wonder then, when all was Love and Sport,
The willing Muses were debauch'd at Court.
(Alexander Pope, *Imitations of Horace*, 1733–8)

Chapter 2 BEAUTY AND THE PURSUIT OF PLEASURE

Being beautiful, of course, did provide other possibilities, if you were prepared to compromise a little of your virtue along the way. Lely's portraits are, explicitly, not just about the beauty of the soul; his women shed their clothing and gaze alluringly. For all of Kneller's neo-Platonic nobility, his 'Hampton Court Beauties' are still shown in a state of 'undress'. This is not official Court attire, but a semi-fictive combination of timeless mythological costume and real informal evening wear: an uncorseted loose-fitting nightgown (which may have slipped from one shoulder just a little bit) was a much more revealing fashion choice.

Beauty of the flesh was, naturally, a temptation but could also be an advertisement. Having your portrait painted in this way

Nymphs by a Fountain
(Peter Lely, *c*1650)

(Peter Lely and his studio, 1666)
Jane Needham (Mrs Myddelton) was,
according to Evelyn, an amateur artist of
some accomplishment; she may, therefore,
have been directly involved in the
composition of her own portraiture.
Here, Lely is perhaps representing Jane
as Mary Magdalene, a reformed sinner: a
popular image choice that reflected the
compromised lifestyles of Court beauties.

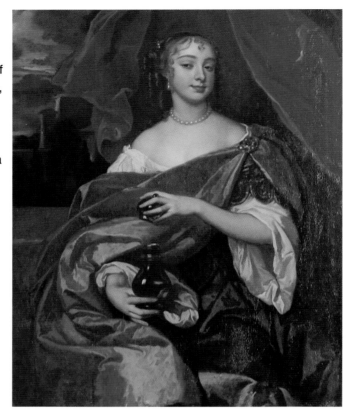

was not just a statement of fashion, but of vanity and ambition.
These paintings can be declarations of self-promotion, if the sitter
herself engaged the commission; or acts of sycophancy, if the
painter was instructed by an admirer; or aspirational essays of
greed, if the painting was the result of a father keen to display
the charms of one of his principal and marketable commodities.
As such, the 'Court beauty' portrait provided one way in which
women could take ownership of their matrimonial futures and
sexual identities, but at the same time exposed the limitations of
their freedom to express themselves outside the parameters of
traditional, male concepts of womanhood.

Jane Needham was painted by Lely as a teenage tearaway. Her
family were Welsh gentry, neither particularly rich nor grand, and
Jane was married, aged 14, to Charles Myddelton, the son of
another obscure country knight; he was 24. She seems to have
exploded onto the Court scene in the mid 1660s with Pepys
exclaiming that he had met 'a very great beauty I never knew or

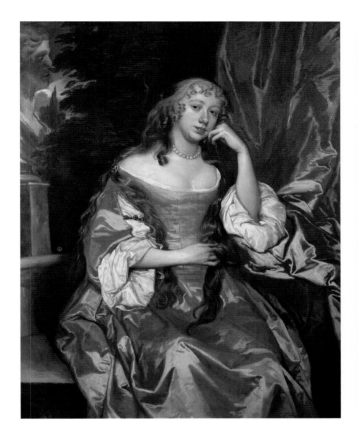

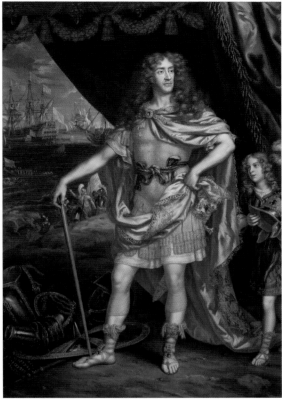

Margaret Brooke (c1647–67)★

(Peter Lely, c1664)

Margaret and her sister, Frances (see page 29), were, according to Anthony Hamilton, 'both formed by nature to excite love in others, as well as to be susceptible of it themselves'.

above right:

James, Duke of York

(Henri Gascar, c1672–3)

A classically armed hero for the Stuart age, Gascar's portrait of the future James II nonetheless also captures the dissolute fripperies of male fashion and late 17th-century portraiture.

heard of before'. She was pursued by all and sundry, and – as usual, it is difficult to extract truth from gossip – she seems certainly to have become the lover of Ralph, the future Duke of Montagu. On the other hand, Jane does not deserve the rather scurrilous reputation that stuck to her, as she resisted being paid for sex by the Count of Grammont, which may conversely explain the rather lame description she receives in Anthony Hamilton's accounts. She was, he says, a 'silly and sentimental beauty', whose 'ambition to pass for a wit, only established for her the reputation of being tiresome, which lasted much longer than her beauty.'

Frances and Margaret Brooke were sisters, the daughters of a knight who had died fighting on the parliamentary side during the Civil War. They were brought to Court, again as teenagers, by their uncle and dangled in front of the King in an attempt to maintain his influence with Charles. Frances managed to extricate herself by a good marriage, becoming Lady Whitmore in 1665,

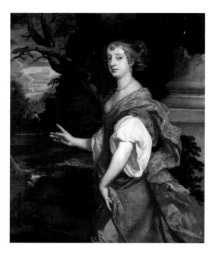

Elizabeth Wriothesley (*c* 1645–90) ★
(Peter Lely, *c* 1665–70)
Amidst the racy stories of intrigue and
adultery, it was still possible for a
woman to be a Court beauty and to lead
a successful, uncontroversial life.
Elizabeth Wriothesley married Joceline
Percy, the Earl of Northumberland, whilst
still a teenager. After his death, the rich
widow married again, to Ralph Montagu,
later Duke of Montagu, before dying in
wealthy middle age in 1690.

and afterward marrying again before dying in her 40s. Margaret, the younger sister, had her head turned by Court temptation. She became the openly acknowledged mistress of James, Duke of York, soon after her own marriage to the poet Sir John Denham. He was 50; she was still a teenager. James was apparently obsessed; Pepys wrote in 1666 that 'The Duke of York talks to her a little, and then she goes away, and then he follows her again like a dog … [He] is wholly given up to this bitch of Denham.' Within a year, Margaret was dead, poisoned, it was maliciously rumoured, by Denham or by Anne Hyde, Duchess of York.

Mary Bagot may also have been the Duke's mistress. The daughter of an impoverished but loyal Cavalier officer, she appears to have been one of the Duchess's Maids of Honour, although there is some confusion here with an Elizabeth Bagot, who may have been Mary's half-sister. Hamilton says that 'Miss Bagot was the only one who was really possessed of virtue and beauty … she had beautiful and regular features and that sort of brown complexion, which, when in perfection, is so particularly fascinating, and more especially in England where it is uncommon. There was an involuntary blush almost continually upon her cheek without having anything to blush for.'

Mary became Lady Berkeley on her marriage, aged about 20, at around the time of this portrait, and later Countess of Falmouth, but her marriage lasted only a year before her husband's brutal death in the Dutch wars of 1665, his good looks blown apart by a cannon ball and his blood splattered all over the Duke of York. Thereafter, the rumour mill, at least, has her in the arms of James himself (perhaps he felt some sort of responsibility for looking after her), who – it was said – thought of marrying her after the death of his first wife Anne Hyde in 1671. Instead, Mary married the charismatic and sometime lover of Nell Gwyn, Charles Sackville, later Earl of Dorset. Mary was clearly a much sought-after prize, a 'trophy wife' claimed by men of the highest rank, despite her relatively modest origins.

We must of course be careful of gossip. Anne Hyde herself, having started her own Court career as Maid of Honour to her future sister-in-law, the Princess Royal, was accused of all manner of infidelities at the time of her marriage to the Duke of York, a particular favourite location being a certain closet built over the water, witnessed by three or four swans. This was in this case part of a scarcely credible attempt to dissuade James from

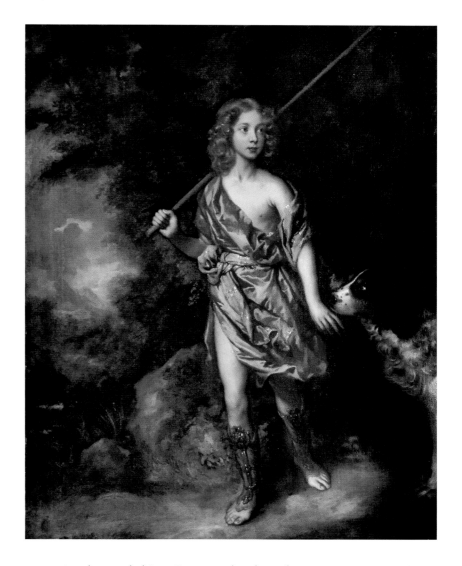

Henry Sidney (1641–1704)
(Peter Lely, *c*1650)
The future Earl of Romney was 'the handsomest youth of his time'. Lely has painted him, aged about nine, in Arcadian costume, a young innocent shepherd-boy as yet uncorrupted by Court life.

marrying beneath him. Frequently, though, women's reputations were discussed, judged and trashed according to family loyalties, matrimonial competition and political expediency. It might be added, however, that Anne Hyde's relationship with her Master of the Horse, 'Handsome' Henry Sidney, later became the subject of Court rumour. Anthony Hamilton claimed that Sidney became infatuated with the Duchess, and she acted simply to 'alleviate his pain', a justifiable action, it was said, given the Duke's own relentless infidelities.

The racy backstory to the history of these portraits has meant that generations of viewers, bemused by Lely's brazen approach

and conditioned by Georgian neo-classicism and Victorian prudishness, have described the 'Windsor Beauties' in less than virtuous terms. Lely was guilty of 'pandering to the depravity of his patrons' and the Beauties themselves were 'pin ups' rather than 'portraits', proud narcissists who, according to critic William Hazlitt in 1824, 'look just what they were – a set of kept mistresses, painted, tawdry, showing off their theatrical or meretricious airs and graces, without one trace of real elegance or refinement, or one spark of sentiment to touch the heart'. 'A set of extremely silly and insipid young creatures', wrote art historian Ronald Beckett in 1951, 'with just enough sense to defend their virtue as long as it suited them to do so.' This sort of misogynistic commentary says more about the writers than their subjects. Historians, whilst spilling lurid ink over their descriptions of Lely's women, have also been keen to transfer their own partial opinions of Restoration 'courtesans' onto Lely's canvases. Barbara Villiers was, according to author Mary Craven in 1906, 'the most incurably vicious of Charles's mistresses' and 'it cannot be believed that her evil passions were absent from her face.'

However, it was not only Lely's heroines who were guilty of moral transgression. Kneller's proud and statuesque Margaret Cecil carried the standard of Restoration unpredictability and illicit daring into the 1690s. Still in her teens when Kneller painted her, Margaret was the daughter of the Earl of Salisbury and was soon to marry John, Lord Stawell. He, unfortunately, died within a year, and afterwards, at the age of 24, she married Richard Jones, Earl of Ranelagh, a man 40 years her senior. It was rumoured that not long after their wedding, the Earl found Margaret in bed with Thomas, Lord Coningsby.

On the other hand, few of either Lely or Kneller's 'Beauties' became long-standing mistresses, and all were young, teenagers for the most part, when they made their debut at Court, preyed upon by professional and persuasive seducers, surrounded by temptation, and pushed forward by avaricious relatives. This is a point often forgotten as serious-minded, middle-aged scholars sit down to judge the lives and loves of Restoration rakes and coquettes: we are frequently dealing with the misadventures of teenagers and the naive fumblings of sexual experimentation, rather than the very grown-up business of adultery and premeditated affairs of deceit. Too much of the Court gossip reads as the frustrated fantasies or the spiteful anguish of a highly imaginative

Margaret Cecil (1672–1728) ★

(Godfrey Kneller, *c*1691)

Not content with seducing Margaret, Lord Coningsby later married her stepdaughter (who was about the same age) against the will of the girl's father, unsurprisingly. Margaret stayed married to her Earl, despite her own alleged youthful indiscretion, and supported him through his dismissal from Court for corruption in 1702.

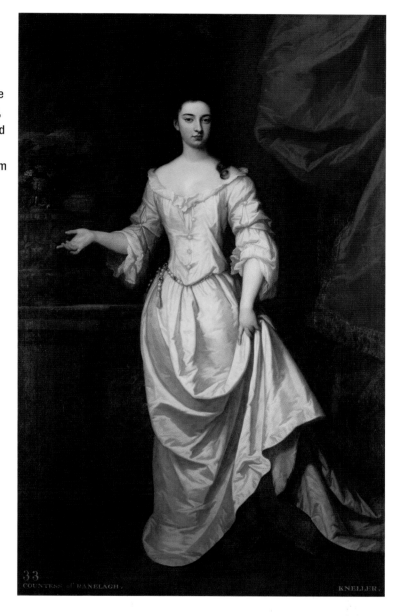

15-year-old, rather than the deeply felt but considered worldly account of an adult love affair.

We should also be careful of judging our Beauties from a distance, of dividing them up into teams of the 'virtuous' and the 'vicious'. Frances Stuart, our saintly 'Britannia' from the previous chapter, eventually eloped and secretly married the King's distant cousin, another Charles Stuart, the Duke of Richmond. The King

was not pleased, but may have been mollified by Frances's belated acceptance of the King's attentions *after* her marriage (although we have only the reported gossip of Charles's word on this). The issue here, for Frances, may have been a concern for matrimonial certainty, rather than virtuous integrity. Either way, Frances returned to Court as a newly promoted Duchess and Lady of the Bedchamber, was widowed in 1672, and died, quiet and respected, in 1702.

Before her marriage, Frances had been Maid of Honour to Queen Catherine and well understood that this was a sought-after position for young unmarried girls, particularly those who did not come with a ready-made dowry and aristocratic pedigree. (Frances was the daughter of a well-connected and well-married politician.) An appointment was usually a reward for loyal family service, but good looks were an important qualification, as a Maid was expected to add lustre and sparkle to the Court, adorning it with feminine charm, beauty and grace. A Maid was thus thrown into the glare of the Court spotlight and quite naturally became the centre of matchmaking gossip and intrigue. As a result, many Maids had very short terms of office, ending in an advantageous marriage, with a dowry paid by the King.

Court gossip could not decide whether Frances, in her original refusal of Charles, was being naive or cunning. Some suspected her of holding out for the highest prize of all, a marriage with the King himself, who some thought detachable from his childless consort: an 'Anne Boleyn' story for the 17th century. Either way, Frances's marriage to the Duke of Richmond was a natural climax to her early Court career.

Frances certainly understood how her beauty could tempt, tease and provoke. The Court was full of lechers dressed up as courteous gallants, whilst new guidebooks like *The New Academy of Compliments*, published in 1669, advised their readers on how to seduce young ladies. Pepys 'glutted himself' staring at Barbara Villiers; even a glimpse of her undergarments hung out to dry was enough to set him off. When properly dressed, the beauty and richness of formal Court costume made female courtiers a very public spectacle. Temptation was everywhere. Evelyn complained, 'To conserve ones self in a Court, is to become an absolute Hero.' Many did not resist, and the Restoration Court became tarnished by its image as a place that tolerated, and even promoted, flirtation, gossip, fornication and adultery. Pepys

Elizabeth Trentham (1640–1713)
(Peter Lely, c1665)
Descriptions from the 17th century of
what men found attractive sound
accessibly modern.

'She was the beautifullest creature I
ever saw: a fine, easy, clean shape; light
brown hair in abundance; her features
regular; her complexion clear and lively;
large, wanton eyes; but, above all,
a mouth that has made me kiss it
a thousand times in imagination; teeth
white and even; and pretty, pouting lips,
with a little moisture ever hanging on
them, that look like the Provence rose
fresh on the bush ere the morning sun
has quite drawn up the dew.'
(George Etherege, *The Man of
Mode*, 1676)

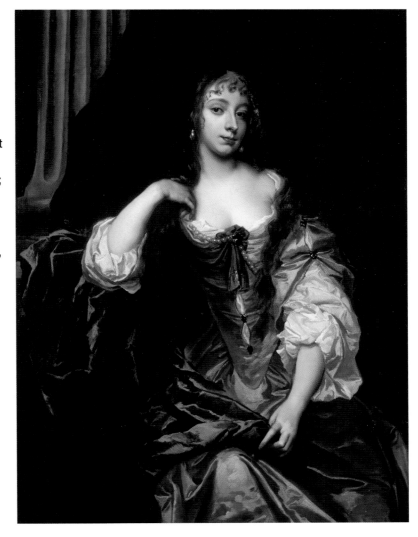

wrote in 1663, 'How loose the Court is … nobody looking after business, but every man his lust and gain.' Or as Andrew Marvell described King Charles himself in 1674, in his *On the Lord Mayor and Court of Aldermen*,

He spends all his days
In running to plays
When he should on his books be pouring;
And he wastes all the nights
In the constant delights
Of revelling, drinking and whoring.

Any woman who had her image painted in the style of Lely could be certain that she was, at the very least, embracing a fashion for provocative portraiture. The title of one angry pamphlet, printed in 1678, speaks volumes, 'A Just and Seasonable Reprehension of naked breasts and shoulders', whilst admonishing, rather poetically, 'this soft and wanton delicacy'. William Sanderson, author of *Graphice* in 1658, warned that portraits of wives 'best become your discretion and her modesty (if she be fair) to furnish the most private or bed chamber, lest (being too public) an *Italian*-minded guest gaze too long at them, and commend the work for your wife's sake.' Margaret Cavendish, Duchess of Newcastle, ridiculed the pretended virtue of Lely's portraits as 'sainting' women for their physical beauty alone, without any regard to their inner grace.

Yet some did not seem to mind very much. In fact, freed from the debasement of an arranged marriage, and emboldened by the licentious Court atmosphere, some women fully embraced their new-found sexual freedoms; some men were not, of course, slow to encourage them along this double-edged path of self-discovery. Barbara Villiers, in addition to being mistress of Charles II, embarked on a succession of sexual relationships with married aristocrats, playwrights and even Jacob Hall, the celebrated rope-walker and dancer.

It is at this point that the line between an imagined portrait of a mythological or historical seductress like Psyche or Cleopatra, and a real portrait of a Restoration beauty, blurs and disappears. Charles II, for one, surrounded himself with both types of portrait: the Italian artist Benedetto Gennari was commissioned to paint a series of racy mythological nudes – Danäe, Venus, Eurydice, Galatea, Diana, Procris and Cleopatra – to satisfy the royal thirst for antique soft-porn. Set amidst the portraits of Court beauties, it was easy for the viewer to conflate their identities and embark on lurid personal fantasies.

When Elizabeth Howard had herself painted, by Gennari, as Cleopatra, she was explicitly aware not only that she was aligning herself with the alluring charms of the Egyptian queen, but also that she was creating a work of art that would itself be the object of prurient desire. The portrait shows Cleopatra holding in her hand the pearl, which she dissolved in a gold cup to prove to Mark Antony that she could host a banquet worth over 10,000,000 sesterces. In outwitting her lover, Cleopatra metaphorically

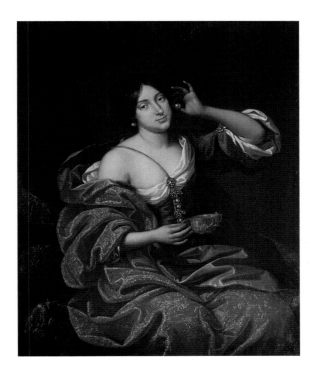 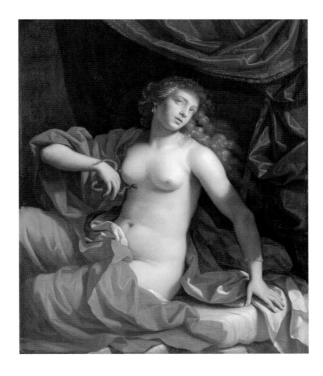

Elizabeth Howard (1656–81),
as Cleopatra
(Benedetto Gennari, c1679–80)
It is tempting to argue that Elizabeth
Howard took an active role in
determining the iconography of this
portrait, revelling in her power over men
and her extramarital freedoms.
It was apparently painted for James,
Duke of Monmouth, Charles II's eldest
illegitimate son, whose own infidelities
were reputedly as famous as those of
his alleged mistress, Elizabeth.

above right:
Cleopatra
(Benedetto Gennari, c1674–5)
The Egyptian princess was an exemplar
of beauty, but she was also an excuse to
display an erotically charged artwork on
your palace wall.

dismantled his dominion over her, and demonstrated that her beauty and her wit were supreme. This role would have been particularly relevant to Elizabeth who became notorious in the 1670s for a series of extramarital affairs, including with the infamous rake and poet John Wilmot, Earl of Rochester, and Charles II's illegitimate son, James, Duke of Monmouth. In a contemporary but anonymous satire, Elizabeth was described as the 'Whore of Honour'.

This pursuit of sexual pleasure and wilful rejection of the moral codes of the previous centuries was epitomised and described most eloquently by Wilmot himself. He led a rich life, full of sex, violence, alcohol and scandal. He bedded actresses (including, possibly, a very young Nell Gwyn, and, definitely, his protégé Elizabeth Barry, with whom he had a child) and led his merry gang on drunken sorties into the dark underbelly of London's nightlife, whilst attending Court and occasionally retreating to his country estate, his wife and his children. Wilmot's poetry, meanwhile, lampoons the self-righteous behaviour of the virtuous toadies and poetasters that eulogised beauty and virtue as untouchable, sanctified 'ideals'. Instead, Wilmot followed the revolutionary secular creed of the philosopher Thomas Hobbes,

A Sleeping Shepherd
(Benedetto Gennari, *c* 1680 – 1)
Gennari's commissions for Charles II
parodied the virtuous innocence of Arcadian
fantasies. This shepherd is 'awakened' by the
attentions of two women, the elder encouraging
the younger towards carnal debauchery.

who saw the 'soul' simply as a function of the body: desire was not something to be restrained, but indulged.

For libertines like Wilmot, pleasure should be pursued because it was more important (and less hypocritical) than the pursuit of virtue. Should you choose to justify it further (and Wilmot, being practically an atheist, did not care to), you could defend even the pursuit of pleasure as a principled quest for spiritual truth. The libertarians argued that, by experiencing the extremes of life, you discovered beauty and truth in unexpected places, in entangled locks of hair, in moments of dramatic intensity, that were closer to the ineffability of divine love, and even virtue, than any textbook explanation that promoted a rigorous (and not very enjoyable) resistance to life's temptations. This is the ultimate defence of the Restoration debauchee: a Don Giovanni vainly searching for ideal beauty in sexual conquest. Even prostitution was defended as a virtuous pleasure (for both participants). In this bucolic fantasy, fresh-faced country girls administered relief from the pressures of urban and Court life, and were themselves, according to novelist John Cleland in 1749, 'restorers of the golden age and its simplicity of pleasures, before their innocence became so unjustly branded with the names of guilt and shame'. The syphilitic and abused whores of London's dark alleys might not have recognised this description.

Much of this sounds like special pleading. Rakehells like Wilmot and his companions, Sir Charles Sedley and Charles Sackville, Lord Buckhurst (later Earl of Dorset), were, despite their ability to be witty, satirical and urbane, boorish and bored aristocrats who took delight in alcohol-fuelled anarchic violence. Most husbands meanwhile, although parasitically attracted to other people's wives, were not at all content to be cuckolded: double standards abounded. As James II's daughter, the young Lady Mary Stuart (who would later, as Mary II, preside over her own Court), observed, 'In two or three years men are always weary of their wives and look for mistresses as soon as they can get them.'

John Wilmot (1647–80)

(Unknown artist, c1665–70)

The Earl of Rochester, courtier, writer and debauchee, bestows a laurel wreath (symbol of the royal poet) on a monkey, presumably a satirical comment on his own literary legacy. Wilmot pursued beauty, but also exposed the absurd vanities and narcissism of his age.

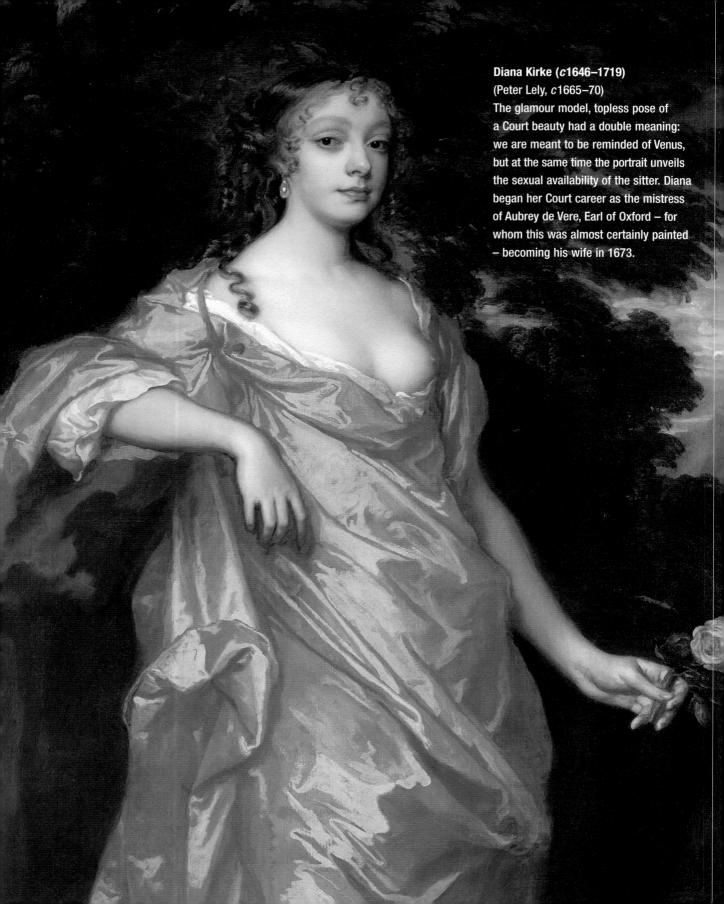

Diana Kirke (c1646–1719)
(Peter Lely, c1665–70)
The glamour model, topless pose of a Court beauty had a double meaning: we are meant to be reminded of Venus, but at the same time the portrait unveils the sexual availability of the sitter. Diana began her Court career as the mistress of Aubrey de Vere, Earl of Oxford – for whom this was almost certainly painted – becoming his wife in 1673.

To you (Great SIR) my message hither tends,
From youth and beauty, your allies and friends.
See my credentials written in my face.
They challenge your protection in this place,
And hither come with such a force of charms,
As may give check ev'n to your prosperous arms ...
Nor can you 'scape our soft captivity,
From which old age alone must set you free.
Then tremble at the fatal consequence,
Since 'tis well known, for your own part, great Prince,
'Gainst us still you have made a weak defence.
(Elkanah Settle, *The Empress of Morocco*, 1671)

Chapter 3 SLEEPING WITH THE KING

Beauty could get you noticed, whilst the attentive courtship of a wealthy aristocrat would bring expensive gifts and potentially a successful marriage. This was all very well, but the fragile availability of teenage Maids of Honour meant that they could all too easily fall prey to professional philanderers and end up *unmarried*, pregnant and abandoned. Women may have found a new freedom at Charles's Court, a liberation even, after the sexual conservatism of the Commonwealth, and discovered that they could wield influence through the strategic use of beauty and sexual promise, but this was a dangerous game. They risked much, not least their reputation within a culture of double standards that encouraged concupiscence but still worshipped female virtue and chastity.

Catherine Sedley (1657–1717)

(Godfrey Kneller, 1685)

Only daughter (and heir) of the notorious rake (and companion of John Wilmot), Charles Sedley, Catherine was later rewarded with the title of Countess of Dorchester. Inheriting something of the wicked wit of her father, Catherine pretended confusion at why James had singled her out, 'It cannot be my beauty because I haven't any, and it cannot be my wit because he hasn't enough of it himself to know that I have any.'

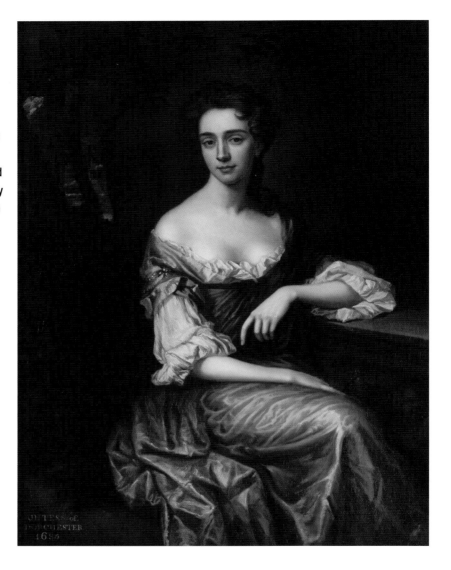

The highest stakes were placed by those women who became the mistresses of married courtiers. This could bring the best of both worlds: a gallant and generous lover, a glamorous lifestyle, and freedom from the country-wife drudgery of a life spent away from Court. This was all the better if you managed to procure for yourself an understanding husband at the same time, who was prepared to be cuckolded in order to share some of the financial rewards brought by your indulgent lover (and also freeing him no doubt to pursue his own adulterous liaisons of choice). Court life was glamorous and lucrative: access to the most important, and

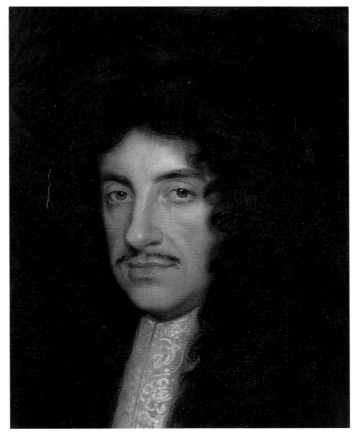

King Charles II

(John Michael Wright, *c*1660–65), detail
The 'merry monarch' was charismatic,
charming and swarthily attractive
(he was also, of course, the King). He
was surrounded by temptation and took
no great effort to resist it. As Pepys noted,
'A man with an erection is in no need
of advice.'

wealthiest, sources of patronage, honours, titles and influence gave women similar opportunities to their husbands, if they managed their beauty and their favours well. One new arrival was knowingly asked by the Court wit, Sir Charles Sedley, whether she intended to be 'a Beauty, a Mistress, a Wit, or a Politician'.

The biggest prizes of all were the royal brothers, King Charles and James, Duke of York, whose libido and generosity were highly prized. James took a succession of mistresses – Arabella Churchill and Catherine Sedley were only the highest profile and most apparent success stories, selected from the ranks of Maids of Honour to James's two wives, Anne Hyde (who had, we have already seen, started her own career as Maid to James's sister) and then Mary, Princess of Modena. Arabella gave James four children: Henrietta, Arabella, James and Henry, the future Dukes of Berwick and Albemarle. Catherine had a number of royal children, but only a daughter, another Catherine, survived to adulthood.

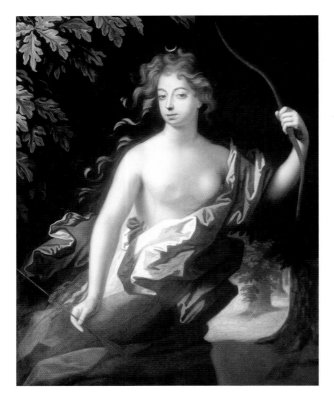

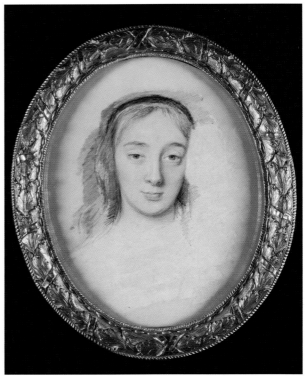

Nell Gwyn (*c*1651–87), as Diana
(Simon Verelst, *c*1675)
Nell's fresh-faced unadulterated –
natural – beauty, and lack of interest in
political chicanery, were a lasting recipe
for success.

'Hard by Pall Mall
Lives a wench call'd Nell.
King Charles the Second he kept her.
She hath got a trick
To handle his prick
But never lays hands on his sceptre.'
(Anonymous verse, 1669)

James's brother, Charles II, indulged his mistresses in public; these were not secret trysts but open and acknowledged affairs. Wilmot wrote, in his 1674 *Satire on Charles II*,

Restless he rolls about from whore to whore,
A merry monarch, scandalous and poor.
Nor are his high desires above his strength;
His sceptre and his prick are of a length.

Chief among the harem were Nell Gwyn, Barbara Villiers and Louise de Kéroualle. All three transformed their fortunes by their relationships with the King; all three managed their own route to power, influence and wealth in different ways. Their reputations (at the time, and since) are starkly different.

Barbara Villiers was the daughter of a viscount, and a second cousin to the notorious political schemer, George Villiers, Duke of Buckingham. As a teenager, part of the fast-living set of frustrated aristocrats, eking out their reduced fortunes and finding forbidden

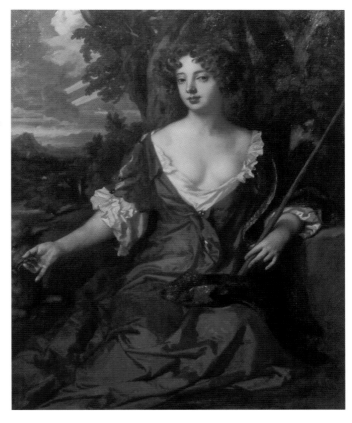

opposite page, right:

Barbara Villiers (*c*1640–1709)

(Samuel Cooper, *c*1662)

In her day, Barbara was a celebrity: on one visit to Oxford, she sat for an hour in her coach so that 'everybody might see her'. Despite her reputation, everyone commented on her 'extraordinary' beauty. This unfinished miniature appears, to modern eyes perhaps, more attractive and intimate than a highly polished portrait. Barbara's direct stare captures some of the alluring magnetism of her sex appeal.

right:

Louise de Kéroualle (1649–1734)

(Peter Lely, *c*1671)

Louise began her career as Maid of Honour at the French Court to Charles II's beloved sister, Henriette. She arrived in England, as a gift from Louis XIV, after Henriette's death in 1670. If Nell was disarmingly guileless and Barbara sexually voracious, Louise's appeal lay in her virginal respectability. Encouraged by the French ambassador, Louise finally allowed herself to be seduced a year later, and became Charles's principal mistress through the 1670s.

pleasures under Cromwell's austere Protectorate, Barbara threw herself into an affair with the 20-something Philip Stanhope, Earl of Chesterfield. Lively letters were exchanged between the two. In 1657, a teenaged Barbara wrote, 'I am never so well pleased as when I am with you, though I find you are better when you are with other ladies, for you were yesterday all the afternoon with the person I am most jealous of, and I know I have so little merit that I am suspicious you love all women better than myself.' Such youthful open-hearted jealousy was soon replaced by a more considered seductive tone, as Barbara teemed up with her friend Ann Hambleton to entice Stanhope to a tryst: 'My friend and I are now abed together a-contriving how to have your company this afternoon. If you deserve this favour, you will come and see us at Ludgate Hill about three a clock … but lest we should give you too much satisfaction at once, we will say no more, expect the rest when you see …' Ann was soon afterwards packed off to her family in Windsor.

'The Night: lady going to bed'

(Fashion plate *c*1690)
For every courtesan exercising her sexual emancipation, there was a wronged wife powerless to control her husband's infidelities. Charles II made Barbara Villiers, and later Louise de Kéroualle, Ladies of the Bedchamber – the principal aristocratic post in attendance on the Queen. Catherine, therefore, was forced to tolerate the daily company of her husband's mistresses.

Eventually, Barbara's correspondence adopts the adult tone of an established lover, 'The joy I have of being with you last night has made me do nothing but dream of you'. These letters are unsubtle testaments to Barbara's maturing sexual confidence and an illicit liaison which survived both their marriages – Barbara married Roger Palmer, a lawyer with good royalist Court connections, in 1659. That same year, Barbara wrote to Stanhope,

> Since I saw you I have been at home and I find the Monsieur [Palmer] in a very ill humour, for he says that he is resolved never to bring me to town again, and that nobody shall see me when I am in the country … send me word presently what you would advise me to do, for I am ready and willing to go all over the world with you.

But Barbara's future lay not with Stanhope, nor with her husband. In 1660, Barbara also began an affair with Charles Stuart; her first child, Anne, born in 1661 and eventually recognised by the King as his illegitimate daughter, was persistently rumoured instead to be the daughter of Palmer or Stanhope. Barbara's first son, Charles, born the following year, was almost undoubtedly the son of the King, and would later be ennobled as the Duke of Southampton. Palmer was, by this point, estranged from his wife and was 'rewarded' for his acquiescence with the distinction of Earl of Castlemaine (although, understandably, he rarely used the title).

Over the next decade, Barbara and Charles's relationship, always it seems tempestuous, apparently deeply physical, survived the latter's marriage to Catherine of Braganza and the new Queen's initial horror at having to accept what was effectively a *Maîtresse en Titre*, an official mistress on the French model, as one of her own Ladies of the Bedchamber. The relationship was also unshaken by the King's occasional one-night stands and the temporary acquisition of other short-term mistresses. Perhaps more surprisingly, their relationship even survived Barbara's own hectic schedule, as she was herself frequently unfaithful – if that is the right word – to the King, not to mention her husband. 'When she has jaded quite, Her almost boundless appetite … She'll still drudge on in tasteless vice, As if she sinn'd for exercise', as Wilmot characteristically put it. Her lovers included John Churchill, later Duke of Marlborough, as well as the actor

James, Duke of Monmouth (1649–85)
(Samuel Cooper, *c*1664–5)
Charles II's eldest son is seen here as a handsome teenager. Chief among the 'fraternity' of illegitimate children that lived and played at the Restoration Court, James was encouraged throughout his life, by rapacious politicians and sycophantic courtiers, to believe he was the rightful Protestant heir to the throne. Fuelled by ambition, he led a rebellion against his uncle James II but was defeated and executed in 1685.

Charles Hart and the playwright William Wycherley. Because of this, the parentage of her children was a source of some dispute, then and now, but Charles eventually acknowledged as his own five of her children, born in as many years during the 1660s.

The King took an active interest in his illegitimate children. Even before 1660, he had already produced at least four. His 11-year-old son, James, now lived at Court (his tragic mother, Lucy Walter, Charles's adolescent but abandoned obsession, had died in Paris a year earlier, probably from syphilis), whilst two children, Charles and Catherine, mothered by Catherine Pegge, the daughter of a loyal Cavalier, were set up in a house in Pall Mall, and yet another, Charlotte, lived with her mother, Elizabeth, and her husband, Viscount Shannon, on their country estate. Later on in their lives, Charles worried about their teenage rebellions and helped to arrange good marriages for each. Barbara's eldest daughter, Anne, caused most concern, eloping in Paris with Ralph, Duke of Montagu (who had also been Barbara's lover). Lengthy letters from an anxious mother were dispatched to the King, which read today much like the careful appeals of a divorced wife to an absent father, requesting that he step in to take his daughter in hand. Charles obliged, and Montagu was relieved of his posts and banished from Court.

Throughout her life, Barbara was both admired and feared. Her thirst for self-advancement, and her readiness to use her beauty and her body to get what she wanted, scandalised and attracted. She was certainly extravagant, 'ravenous' as Bishop Burnet described her, acquiring – and spending – enormous amounts of money from the royal purse, alongside properties, grants of land, and tax revenues; she could be 'querilous, fierce, loquacious, excessively fond or infamously rude' as Mary Manley, her companion, later wrote. She was a woman of extremes, capable of love and hate: Stanhope, requesting a portrait of her, explained 'for then I shall have something that is like you, and yet unchangeable'. Barbara's own letters, to Stanhope and to the King, reveal a passionate woman whose attraction to Charles must have stemmed from her shameless submission to the power of her emotions: 'You know as to love, one is not mistress of one's self.'

Barbara was also a genius at self-promotion; her artistic commissions, particularly from Lely – whose chief muse she became – demonstrate a complete parody of the earnest virtuous

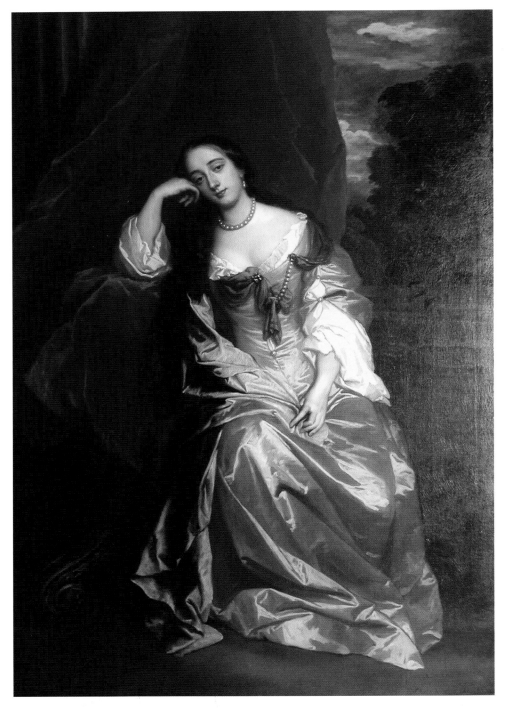

Barbara Villiers
(Peter Lely, *c*1662)
'It was beyond the compass of art to give this lady her due as to her sweetness and exquisite beauty', Lely is meant to have said, but Barbara was the artist's chief muse and the subject of a number of beautiful portraits, which became much sought after by voyeuristic collectors. There were 13 unfinished copies of Lely's portraits of Barbara in his studio when he died.

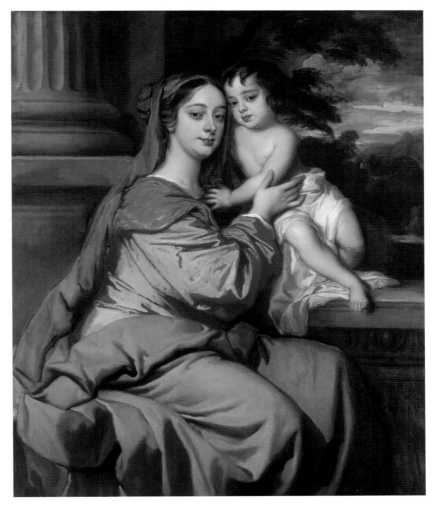

Barbara Villiers, with her son,
Charles FitzRoy (1662–1730)

(Peter Lely, *c*1663)
This portrait was recognised at the time as a self-conscious representation of Barbara as the Virgin Mary. Barbara may well have been implicitly mocking the self-important virtuous imagery of Restoration portraiture. Charles II, it seemed, shared the same sense of humour, rewarding Barbara with the Duchy of Cleveland in 1670, 'by reason of her own personal virtues'.

symbolism of baroque portraiture. Lely painted her as Minerva, the goddess of wisdom, whilst John Michael Wright portrayed her as St Agnes, the shepherdess, the patron saint of virgins. These are conventional 'beauty' portraits, associating Barbara with the virtues and qualities of her disguises. However, Barbara knew what people thought of her and realised that, as the official royal whore, it was difficult to persuade people of her virtue. As ever, she rose to the challenge.

Lely's earliest portrait of Barbara positioned her in a pose that would have been recognisable in the 1660s as Mary Magdalene: the fallen woman saved through the love of Christ, just as Barbara herself is excused her infidelity to her husband through the love of

Nell Gwyn, as Venus

(Peter Lely, *c*1668)

John Dryden described Nell's oval face, clear skin, hazel eyes and warm bronze-red hair, streaked with gold. She also possessed, apparently, the smallest and prettiest feet in the country. Aphra Behn dedicated her 1679 play, *The Feigned Courtesans*, to Nell with a tribute that described how she gladdened 'the hearts of all that have the happy fortune to see you, as if you were made on purpose to put the whole world into good humour'.

the semi-divine King of England, Charles II. This is also a stunningly beautiful portrait, one that captures clearly her raven-haired beauty and the sensuous invitation of her 'sleepy-eyed' expression. This visualisation of Barbara's attraction became a 'look' in the modern sense of the word. It influenced both Lely's conception of ideal beauty (which he then imposed, to an extent, on his other sitters) and other women's perception of beauty too, so that Barbara's style, dress and portrait poses were copied and followed, and not just by those seeking a similar scandalous route into the King's bedchamber.

Even more daringly, Lely painted Barbara with one of her illegitimate royal sons, probably her eldest, Charles FitzRoy. This is indisputably a portrait that suggests an image of the Virgin Mary and the Christ child. Indeed, during the 18th century, a version of this portrait in a French convent was for many years believed to be just such an orthodox image, until someone pointed out the real subject and the painting was quickly removed. Barbara seems to be saying that her children, far from being the illegitimate bastard offspring of the royal whore, are the semi-divine children of a god-like King. In one work of art, Barbara has turned herself from a courtesan to a humble vessel fulfilling God's will.

As the King's mistress, Barbara was handsomely rewarded with wealth, gifts, estates and titles, becoming Duchess of Cleveland in her own right in 1670. She retained a set of apartments at Court and became Keeper of Hampton Court Palace in the same year. By this point, her physical relationship with the King may have been over, and she had been supplanted as 'principal' mistress by Louise de Kéroualle, but she always remained influential at Court, a magnet for intrigue and a conduit to the King for those seeking advancement or hoping to influence royal policy. This was mainly because of her status as the mother of five of Charles's offspring, especially as the King had no legitimate children of his own.

If Lely's portraiture of Barbara Villiers mocked conventional allegorical representations of Court beauties, his most famous painting of Nell Gwyn was more immediately erotic. Nell sat for Lely in the nude, and Charles enjoyed visiting the painter's studio to watch. Charles hung the portrait in one of his private rooms at Whitehall Palace, artfully concealed behind a landscape painting, to be enjoyed at leisure by the King and his favoured companions,

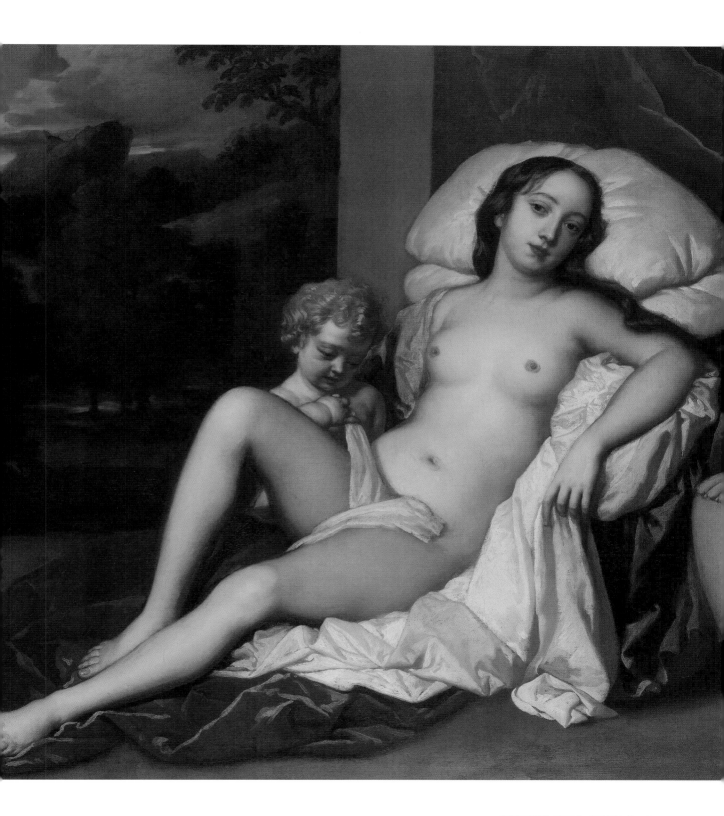

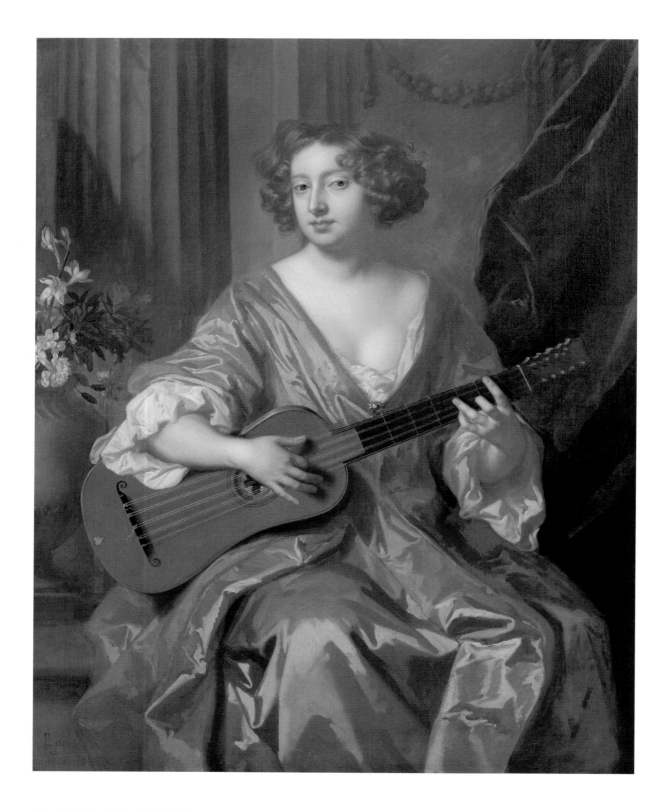

Mary Davis (*c*1648–1708)

(Peter Lely, *c*1674)

'Moll' was Nell's contemporary, and friendly rival, on the stage and in the royal bed (Nell was the better actress, Moll the better dancer). Nell apparently once laced Moll's food with a purgative drug so that she would not be able to 'perform' for the King.

surrounded by Charles's other soft-core but mythological 'friends', his 'Danäe' and his 'Sleeping Venuses'. As Dryden described, 'Misses there were, but modestly conceal'd, Whitehall the naked Venus first revealed.'

Nell's rise from teenage orange-seller at the theatre, to actress, to royal mistress, had also seen her progress from the actor Charles Hart, to the courtier Charles Sackville, and then to Charles Stuart. Charles II was, in Nell's own words, her 'Charles the Third'. Her rise to prominence and wealth echoed the ambitions of Dryden's Jacintha from his 1668 play, *An Evening's Love*, a part that Nell herself performed on stage. When asked what a gentleman is to hope from her, Jacintha replied: 'To be admitted to pass my time with, while a better comes: to be the lowest step in my staircase, for a knight to mount upon him, and a lord upon him, and a marquess upon him, and a duke upon him, until I get as high as I can climb.'

Her longevity as Charles's 'pretty, witty Nell' (compared with other mistress-actresses like Moll Davis, and plenty more besides) was testament not just to her physical attractions but to a fabled sense of humour, and a complete faithfulness to her royal lover unrivalled, seemingly, by any of Charles's other mistresses. Nell was also relatively independent from the cliques and familial interests that surrounded aristocratic beauties. In the 1670s, she stood in apparent contrast to Louise de Kéroualle, a foreign Catholic import who was promoted by her friends, and portrayed by her enemies, as a 'creature of France', a tool with which to influence English foreign policy.

Generally, mistresses who had been explicitly pushed forward as part of a campaign to influence the King did not last long; Charles did not care to have his leisure time interrupted by a political agenda. Wilmot advised his friend Nell to:

Live at peace with all the world, and easily with the King: never be so ill-natur'd to stir up his anger against others, but let him forget the use of a passion, which is never to do you good: cherish his love wherever it inclines, and be assur'd you can't commit greater folly than pretending to be jealous; but, on the contrary, with hand, body, head, heart and all the faculties you have, contribute to his pleasure all you can, and comply with his desires throughout.

Nonetheless, Nell's Pall Mall home was a good place to catch Charles off-guard and relaxed, whilst Barbara's 'King Street clique' included royal ministers keen to establish informal strategies for influencing the political agenda. Louise's palace bedchamber became known as the unofficial cabinet council, and a particularly well appointed one at that. Inside, the most important political bigwigs drank the finest champagne, listened to the best musicians, and admired the elaborate Gobelins tapestries and Louis XIV furniture. Louise herself was made Duchess of Portsmouth, and acquired riches and jewels that eclipsed the collection of the Queen, causing the jealousy and opprobrium of the chattering classes. As a characteristically disgusted Evelyn commented (rather optimistically perhaps), 'What contentment can there be in the riches and splendour of this world, if purchas'd with vice and dishonour!'

All the royal mistresses, to different degrees, succeeded in using their beauty to acquire wealth and the fashionable accoutrements of high-society living that proclaimed their success on the Court stage. Each had good credit with all the superior London merchants, especially dressmakers, silversmiths and jewellers. Single jewellery items like diamond rings were bought for thousands of pounds apiece (£1,000 then being roughly equivalent to £75,000 today), while dresses and accessories were purchased in bulk. Nell bought gloves and shoes by the dozen: 'scarlet satin shoes with silver lace, and a pair of satin shoes laced over with gold for Master Charles', the elder of the two boys that Nell bore to the King. A royal mistress had to look the part, and royal children, even illegitimate ones, had to be clothed and educated.

A significant portion of a royal mistress's income was also spent on purchasing gifts for courtiers and servants, artistic patronage, the church poor box, hospitals and the considerable expense of entertaining. In 1671, Louise gave a dinner for the entire English Court, paying for food, actors, musicians, theatrical sets, costumes and fireworks. The King paid, directly or indirectly, for nearly everything; official pensions and specific tax revenues were commandeered, and supplemented by single under-the-counter payments from royal accounts (the 'Secret Service' fund, in particular, covered a multitude of sins).

To match the European decadence of her palace apartments, and her expense account, Louise also imported a French-styled concept of female beauty, through her patronage of continental

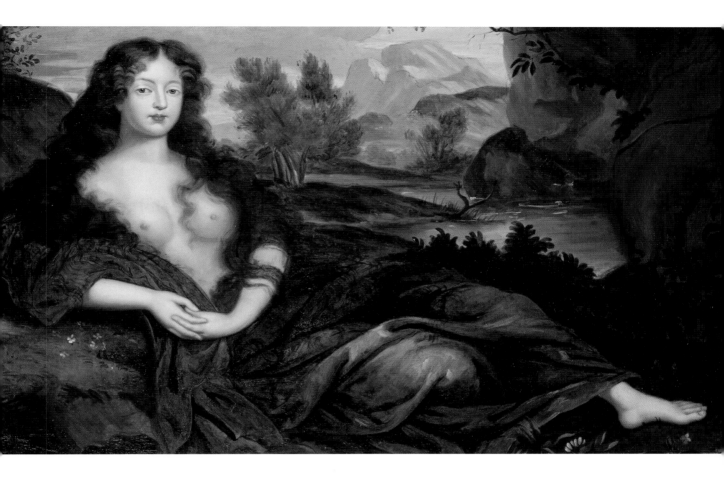

Louise de Kéroualle, as Venus
(Henri Gascar, *c*1674)
Nell called Louise 'Squintabella' (she had a slight cast in one eye) and 'The Weeping Willow' (she affected great remorse at the death of little-known aristocratic relations). Others called her a lot worse. Charles II simply called her 'Fubbs', the small and chubby bedfellow of his later, less sexually active, years.

artists. Her portraiture has a soft-focus feel, a delicate loveliness, rather than the viscerally sexy, arched portraits of Lely – although Louise made sure she sat for him too. Louise did attempt at least one artistic essay in a more provocative style. In 1674, she was painted by Henri Gascar as an undressed Venus, lacy chemise open to the waist, sensually draped over a be-cushioned couch: a scene perhaps familiar to Charles from his visits to Louise's apartments (or, as Wilmot described it, 'Within this place, a bed's appointed, For a French bitch and God's anointed.'). Nell, in what seems to be a characteristic exercise in mischief (the kind of thing that apparently greatly amused Charles), managed to pinch the chemise and had herself painted by Gascar in a slightly more explicit pose, lying back on a bed of flowers.

Despite the occasional artistic competition, Louise's attraction for the King was probably of an entirely different quality from his devotion to Nell. Louise brought a continental aristocratic preciousness to the English Court, the charm of innocent virginity in stark contrast to the wealth of experience accumulated (in their different ways) by Barbara and Nell. Once seduced, Louise was also, by her very identity as a Frenchwoman in the English royal bed, a political creature. She was courted by French diplomats and used by Charles as a covert symbol of his secret pro-French foreign policy. Nonetheless, there was, as with Barbara and Nell, a genuine love that survived for over a decade. Even on his deathbed, the King told his brother, 'I have always loved her, and I die loving her.'

Louise's pre-eminence over Nell also measured in cold cash: Nell, because of her humble background, was excluded from the richest rewards available to a royal mistress. Class mattered – so Nell generally received much less money from the royal purse than Louise or Barbara – one surviving (and not exhaustive) account for the three years between 1676 and 1679 lists payments surpassing £55,000 for Louise (over £4,000,000) but only £16,000 for Nell. The latter, of course, understood this, and maintained her position and influence because she accepted it, and used her self-mocking wit to remain popular, not only at Court, but also with the wider public. Faced, for example, with an angry crowd, who mistook her coach for that of Louise – the mistrusted foreigner, Nell was said to have signalled to the driver to halt, stuck her head out of the window, and exclaimed, 'Pray, good people, be civil, I am the *Protestant* whore!'

All of this was a state of affairs that could not have arisen at any earlier period in English history. The sexual revolution among the elite enabled women, who were prepared to take the risks, to use their beauty as a tradable commodity to acquire wealth and influence, and a legacy for their children. Nell may have ended her days a commoner (ennobling an orange-selling actress was a step too far), but her eldest son became Duke of St Albans in 1684 before her death. Their success, however, should not obscure the experiences of the countless other candidates for royal approval who were shepherded up the King's private backstairs by the royal brothelkeeper, William Chiffinch, Page of the Bedchamber, but whose names and fates have vanished from history.

Nell Gwyn

(Gerard Valck, from a painting by Peter Lely, *c*1673)
Portraits of Charles II's mistresses were copied in the artists' studios and also widely circulated as engraved prints. Baptist May, Keeper of the Privy Purse, and – as Pepys described him – 'court pimp', had eight portraits of women in his Court lodgings, at least four of them royal mistresses.

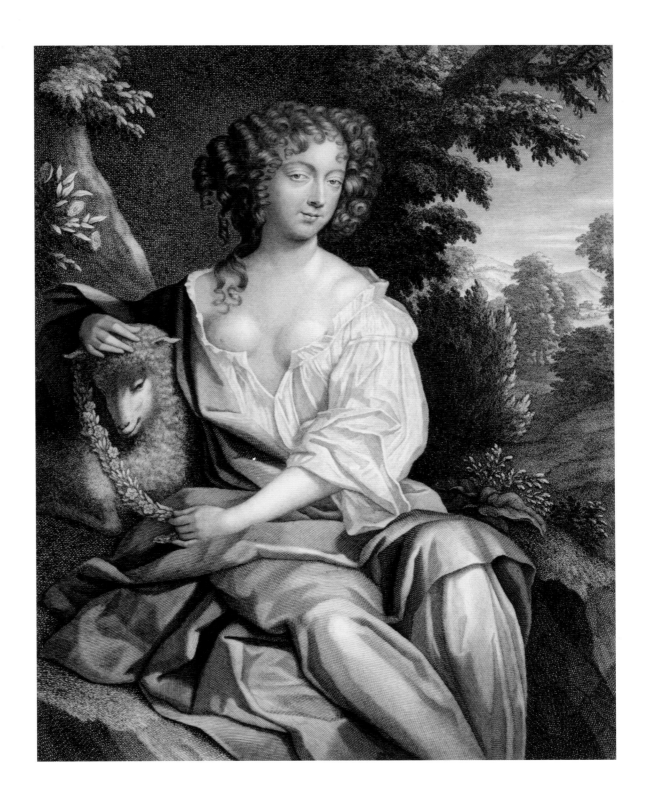

Every lass she will paint her face
To seem with a comely grace,
And powder their hair
To make them look fair
That gallants may make them embrace
The more to appear in Pride
They often in Coaches ride,
Drest up in their knots
Their jewels and spots,
And twenty knick-knacks beside.
(Unknown author, *The Innocent Country Maid's Delight*, c1685)

Chapter 4
THE BEAUTIFUL LIFE: FASHION, STYLE AND GLAMOUR

The Court was, throughout this period, the hub of fashionable society. It formed 'the Seat and Foundation of Sports, Pleasures, Enjoyments, and all the Polite and Magnificent Entertainments', as Anthony Hamilton wrote in the early years of the 1700s. On Charles II's restoration, the pious reserve of the Cromwellian regime was swept away and replaced by a culture of magnificence, hedonism and partying. The public theatres were reopened, new pleasure gardens established, and lavish dinner parties and grand balls became the order of the day. The Court beauties were the 'reigning toasts' of this decadent society; they were to be found in the theatres (even on the stage itself), parading in the parks, dancing, dining, flirting, gambling and drinking.

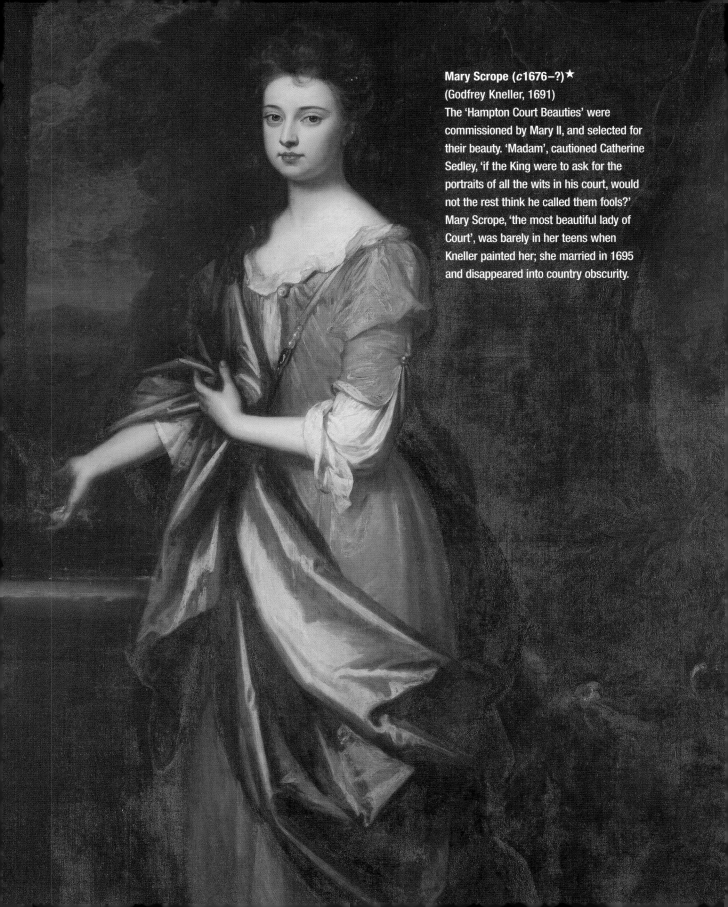

Mary Scrope (*c*1676–?)★
(Godfrey Kneller, 1691)
The 'Hampton Court Beauties' were commissioned by Mary II, and selected for their beauty. 'Madam', cautioned Catherine Sedley, 'if the King were to ask for the portraits of all the wits in his court, would not the rest think he called them fools?' Mary Scrope, 'the most beautiful lady of Court', was barely in her teens when Kneller painted her; she married in 1695 and disappeared into country obscurity.

Mary Bentinck (1679–1726) ★

(Godfrey Kneller, *c*1691)
Mary was the daughter of Hans
Bentinck, the Earl of Portland, and one
of William III's closest friends. As
Superintendent of the King's Gardens,
the Earl oversaw the building of the
little Water Gallery by the river at
Hampton Court, where this portrait of
his daughter was first hung.

An average day for one of Lely's or Kneller's Court beauties consisted of a dizzying round of social engagements, all conducted in extravagant style. Catherine of Braganza established 'drawing rooms' – informal assemblies where the political and social elites gathered to pay their respects to the monarch, to seek royal favour, to hear the news and to gossip with friends. These occasions were often accompanied by gaming with cards and dice, sometimes for vast sums of money: in one week, Barbara Villiers allegedly lost £25,000 (about £1,875,000) at 'basset'. Barbara, Nell and Louise also hosted more select 'salons' at their London residences, where the King was entertained by his favourite musicians, the conversation of writers and popinjays, and the company of beautiful women.

Kings and queens also dined at Court in front of a host of admiring spectators, served on bended knee by their gentlemen- and ladies-in-waiting, the cream of aristocratic society. They could choose from a rich variety of native and exotic foods: partridges and larks, flounders and herrings, accompanied by the more familiar beef, veal, chicken and pork dishes; nutmeg, cinnamon, capers, almonds, saffron and cloves flavoured the recipes, and carrots, turnips, potatoes and mushrooms, oranges, pears and lemons balanced their diets. Macaroons, sugar candy, cheesecakes and custard satisfied those with a sweet tooth, and in 1686 James II became the first person in England to be recorded trying out the new exciting dessert idea – ice cream! All of this could be washed down with wine, brandy and ale – or another new arrival from France, champagne.

Court entertainment took place within gorgeous state apartments decorated in the extravagant baroque style. Between 1699 and 1701, William III filled his new rooms at Hampton Court with ancient tapestries, canopies and beds of silk and velvet, gilt tables and candle stands, shimmering silver, crystal and glass – furnishings that aped the opulent fashions of the French Court and the magnificent palaces of his great rival, Louis XIV. Mary II imported printed calicoes from the East, and collected blue-and-white 'Delftware' from Holland and porcelain from China, which she arranged in towering pyramids on shelved palace mantelpieces. The King also commissioned the Italian painter Antonio Verrio to adorn the palace walls and ceilings with tales of classical martial heroes, and amorous gods and goddesses: antique evocations of elegance and decadence.

Charles II dining in The Hague

(From a print by Pierre Philippe, *c*1660–4)
Before his return to England, Charles entertained an itinerant Court-in-exile, sustained by the loyal support of his followers. In 1660, in recognition of the King's elevated prospects, the Dutch government treated the English Cavaliers to a banquet served on gold plate: at last, the kind of magnificence and elegance that Charles craved was within his reach.

Outside the palace walls, the beautiful life was paraded in public in the new urban open spaces of London's expanding 'West End', the royal theatres at Drury Lane and Dorset Gardens, and the royal parks of St James's and Kensington Gardens. Sedan chairs and carriages were the favoured means of elegant transportation: Nell Gwyn had a gaudily upholstered four-horse coach, painted on the outside with a whimsical coat-of-arms (despite her modest origins); she also had a smaller, sporty 'chariot', ideal for racing down the Mall of a morning. 'The great Duchess of Cleveland', it was meanwhile reported, not to be outdone, 'goes about the streets with eight horses in her coach, the streets and balconies and windows full of people to admire her.'

At Court and in public, aristocratic men and women 'performed' for and in competition with each other, seeking to enhance their popularity, their celebrity and, perhaps, their matrimonial or sexual prospects. Being beautiful helped enormously, but good looks were only one element of a successful 'beautiful performance'. Courtiers were required to know the complicated rules of etiquette that governed all kinds of social interaction, from fighting a duel, playing at cards, conversing, or dancing a minuet, to even entering a room or sitting down. Upon a first meeting, courtiers were

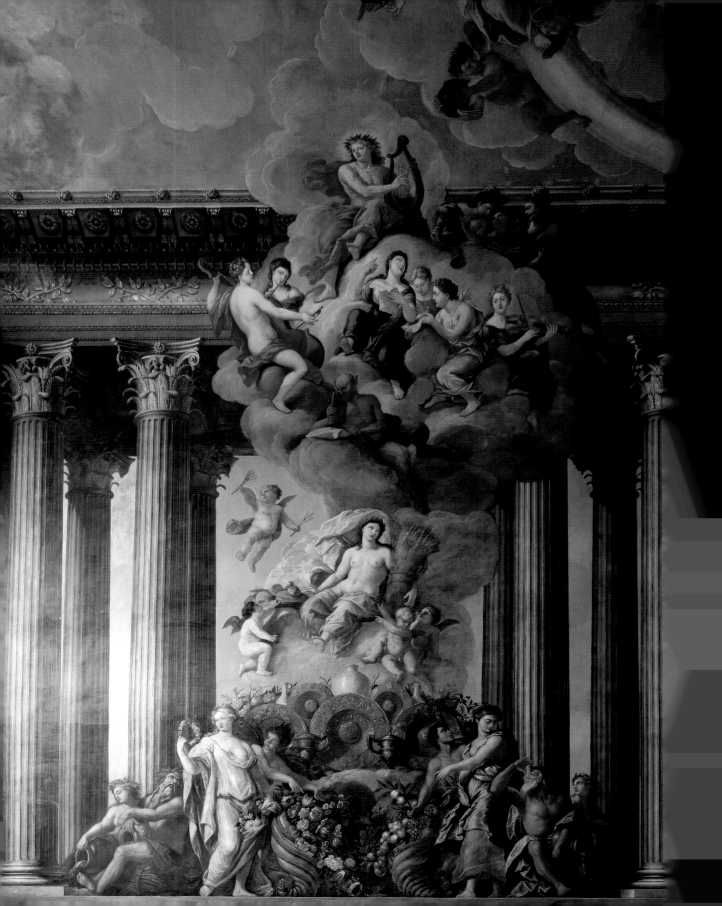

The King's Staircase at Hampton Court is a complex baroque essay that asserts the benefits of William III's 'Glorious Revolution'. On the north wall, Apollo, joined by the gods and goddesses of the arts, of nature and agriculture, presides over an ostentatious array of gold plate. This painted display mirrored the real grandeur of the state apartment interiors, and both were meant to dazzle and impress.

required to bow or curtsey graciously to one another; at Court, they were not to sit down in the royal presence unless invited (hence the few chairs in state apartments), or to wear a hat when the King was in the room, and they were never to place themselves before someone of superior rank. No one who had been acknowledged by the monarch was allowed to leave the room by turning his back: instead, the proper etiquette was to make three low bows or curtsies and then walk backwards, facing the sovereign. Ignorance of these rules could mean embarrassment, at best, or removal from the guest lists for the poshest parties, at worst.

The most desirable attribute of all was elegance. Courtiers were required to display impeccable manners, eloquent conversation, and refined dancing skills, all governed by an easy graceful felicity that ought to look natural and untutored. Angular or hurried movements and excessive speech were to be avoided. According to the satirical writer of *News from Covent Garden: Or the Town-Gallants Vindication* of 1675, it was necessary that a gentleman knew:

> All the accomplishments that are required to build up a man of worth, to be acquainted with the means, and exactest garbs, the most fashionable expressions, the winning addresses, and all the finenesses of language doubled perfum'd: the complements, passes, and re-passes; parties, and re-parties, and the vast skill of serenading and the mystery of tending a visit, with approved and modish accuracy. 'Tis only from exact and curious imitation of our deportment, that young gentlemen can learn these perfections.

Certainly, some degree of training by a dancing master was needed. In 1694, the family of Anne South, a newly appointed Maid of Honour, requested a delay before she came into waiting for 'Mr Issack [the Court's dancing master] to show her how to come into a room, for at present she cannot stand still without tottering'. Like physical beauty, graceful conduct and fine manners read as signs of inner goodness and virtue. They also provided an opportunity to display the body, manipulating it into pleasing shapes that were as alluring as a pretty face, a key talent for an aspirational Maid.

Being beautiful meant wearing the latest fashions and the richest, most stylish clothes. The entertainments and parties of fashionable society were opportunities for dressing up and showing off. On

The Mall, from St James's Park
(Marco Ricci, 1710)
The Mall was *the* place to announce your sophistication and success, a place for high fashions and the haunt of 'fluttering fops of honour'. The women wore long formal 'mantuas' with towering headdresses, and the men richly embroidered coats, lace cravats and shirt cuffs, with high-heeled shoes.

 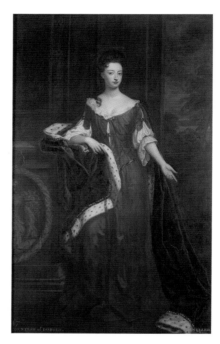

Charles Sackville (1638–1706)
(Godfrey Kneller, c1700)

Mary Compton (1669–91) ★
(Godfrey Kneller, c1691)

Charles, Earl of Dorset, models the modish 'undress' look in this portrait. A fur turban replaces the formal wig, and an opulent blue and gold damask gown is casually arranged so that it reveals the pink satin lining: elegance without effort. Sackville, uniquely, managed to marry both a 'Windsor Beauty' and a 'Hampton Court Beauty' (as well as being Nell Gwyn's 'Charles the Second'). Mary Compton became Sackville's second wife in 1685, before dying of smallpox at the age of just 22, shortly after this portrait was completed.

royal birthdays in particular the Court were expected to appear in their finest gowns and suits and, for ladies, the full complement of their family jewels. Following French styles (or fopperies, as they were satirically known), dress, make-up and hairstyles all became more extravagant and embellished. The 'perfect gilded theatres' of The New Exchange in the Strand (a kind of Restoration shopping mall) and the luxury shops in the Royal Exchange offered fine and exotic textiles, as well as the latest trends in clothes and accessories. Anthony Hamilton described 'pocket looking-glasses, elegant boxes, apricot paste, essences and other small wares of love' arriving 'every week from Paris'.

The Court beauties painted by Lely and Kneller were the fashion icons of their day, yet, paradoxically, their portraits give little sense of the complexity and formality of their dress. The revealing clothes and loose draperies worn by the women were based upon pastoral and classical costumes, and fashionable forms of 'undress' or 'dishabille': the loose gown or shift that a woman might wear in the morning before she dressed for the day. The informal style was an indication of status: an aristocratic host could receive visitors in 'undress', but only if he or she was socially superior to his or her guest. Portraits of men might show them either in heroic, classical armour, or in loose robes like 'Roman' tunics. The antique references were intended to flatter the subject, lending them the authority of an imperial emperor, or the wisdom of an ancient Greek philosopher. These costumes were also meant to be timeless, to avoid becoming dated, as fashions and styles changed from decade to decade. 'Great Masters in painting,' Joseph Addison explained in *The Spectator* of 1711, 'never care for drawing people in the fashion: as very well knowing that the head-dress or periwig that now prevails … will make a very odd figure and perhaps look monstrous in the eyes of posterity. For this reason they very often represent an illustrious person in a Roman habit.'

Formal Court dress was far more splendid and bejewelled than is apparent from most portraiture. Ladies wore a mantua, a gown with a stiff bodice, elbow-length cuffed sleeves and a skirt that was pulled back into a gathered train to reveal the petticoat underneath. Mantuas were commonly made up in silk or silk brocade with a different coloured or patterned lining (that was revealed when the skirt was tied back) and richly decorated with embroideries, braids and fringing; the petticoats were similarly adorned, and from the 1710s hoops of bamboo or whalebone

were also added to give them a fuller shape. Such a dress was incredibly costly. In 1676, Carey Fraser's costume of ermine, velvet and cloth-of-gold at a birthday ball was rumoured to have cost her £300 (about £22,500 today) – a sum so extravagant that, according to Grace, Viscountess Chaworth, it dissuaded her suitor, Sir Carr Scrope, 'who is much in love with her, from marrying her, saying his estate will scarce maintain her in clothes'.

Fashionable ladies carried a number of exquisite accessories, including leather gloves, fans and small velvet purses to hold their gaming money. Gloves were often perfumed (jasmine, frangipane, orange, violet and narcissus being favoured scents), or a 'jessemy butter' – an aromatic ointment or scented powder – was rubbed onto the hands before they were put on. In the last quarter of 1682, Henrietta Herbert, the Countess of Pembroke (and sister of Louise de Kéroualle) ordered from a Parisian haberdasher no fewer than 99 pairs of gloves, many of them scented with orange-flower and amber perfumes. Gloves and fans were also the traditional gifts given by lovers. Fans in particular were associated with courtship rituals: whether open or closed, drawn across the cheek or twirled in the hand, a fan could be used to convey, emphasise or mask the emotions (or availability) of the lady carrying it. As writer and poet Soame Jenyns explained,

What daring Bard shall e'er attempt to tell
The powers that in this little engine dwell?
What verse can e'er explain its various parts,
Its numerous uses, motions, charms and arts?
(*The Art of Dancing*, 1729)

Masks, covering half or all of the face, were worn on certain occasions up until the 1690s. These helped to protect the face (and make-up) from the weather and the heat of a sticky crowded ballroom, but they also made possible the 'glorious invention' of 'masquerading'. For a Court that positively encouraged flirtation and illicit assignations, the ability to hide your identity behind a fan or a mask provided opportunities for mischief and deception. Sir Charles Sedley told Pepys that he had been utterly beguiled by a woman at the playhouse who appeared masked, and 'did talk most pleasantly with him', gave 'many pleasant hints of her knowledge of him', but refused to tell him her name.

Queen Mary II

(Jan van der Vaart, 1688)
Mary's household account book of 1694
lists 31 mantuas and gowns, taffeta,
velvet and satin fabrics, satin shoes
with gold and silver lace, gloves, furs,
fringes, ribbons, fans, patches and
'commodes of wire'– the tottering
headdresses of the 1690s, as displayed
in this rare portrait of formal Court dress.

Men were expected to dress splendidly too. Pepys was very clear on the value of dressing finely: 'I must go handsomely whatever it costs me; and the charge will be made up in the fruits it brings.' By the late 1660s, the Court dress worn by gentlemen consisted of a formal suit – a coat and waistcoat to the knees, elaborately decorated with braid and embroideries in coloured silks or gold and silver threads. This was worn with breeches and a linen shirt with lace at the collars and cuffs, a lace cravat (which like the modern tie formed the focal point of a man's dress), a hat and a sword. The dress sword was a reminder of male heroism, but over this period became less an actual weapon and more an article of jewellery.

Such costumed finery demanded equally splendid hairstyles. For women it was fashionable to have their hair tightly curled

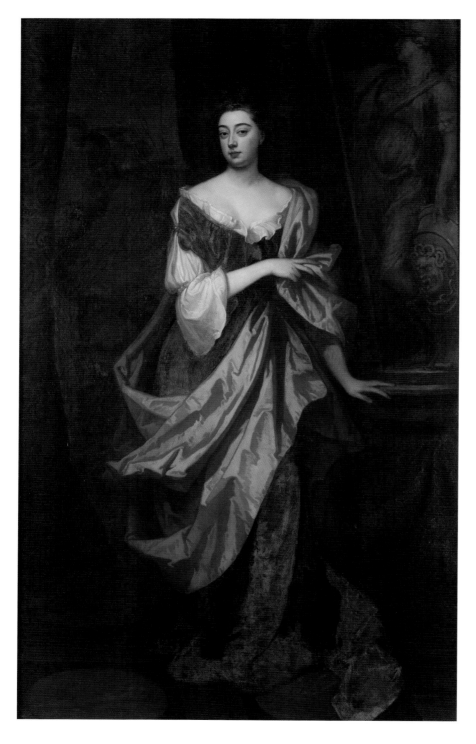

Carey Fraser (*c*1658–1709) ★
(Godfrey Kneller, *c*1691)
Carey was initially thrust forward
into the Court spotlight by a
supportive mother, with ambitions
of becoming a royal mistress.
Thwarted, her family arranged
for a clandestine marriage with
Charles Mordaunt, the future
Earl of Peterborough (they were
both under the legal age).

Sarah Jennings (1660–1744)
(Christian Zincke, 1711)
Miniature portraits were both essays in beauty, and beautiful objects in their own right, particularly when painted in enamel, as this lent the finished likeness a glossy prettiness. Sarah Jennings, domineering friend of Princess Anne, became Sarah Churchill on her marriage to the future Duke of Marlborough in 1678: female virtuous beauty matched with male military prowess.

and bunched, as shown in Lely's portraits. Foreheads were plucked back and decorated with spirals of hair described as 'favourites'. *The Fop Dictionary* of 1700 also described: 'Les Meurtrières – Murderers, a certain knot in the hair, which ties and unites the curls' and 'Le Crève-coeur – Heartbreakers, the two small curl'd locks at the nape of the neck'. For all these fashionable affectations, the French aristocrat Madame de Sévigné remarked that a hundred curl papers were needed, which had to be kept in all night. For especially complicated hairstyles, the addition of false hair was sometimes required, occasionally applied in a contrasting colour. Towards the end of the century, hair got bigger. The ideal fashion pulled the fringe almost straight back from the forehead and combed it over a cushion, with the hair at the back arranged in a wreath of curls and brought sloping down each side of the face. Wigs became towering constructions, decorated with an elaborate headdress of lace and ribbons. Writing in *The Spectator* in 1711, Addison marvelled at the 'Female architects who raise such wonderful structures out of ribbons, lace and wire'.

Wigs for men also became indispensable accessories. Long hair may have been fashionable, but it was difficult to keep clean, so men cut their hair short and replaced their flowing Cavalier locks with expensive big wigs. Between 1700 and 1710, gentleman's wigs ballooned upwards, either side of a central parting, before cascading down to the shoulders. They were thickened with 'pomatum' (a 17th-century hair gel), powdered and perfumed. Such wigs required correct deportment to keep them straight, and accordingly they became yet another attribute that distinguished the proper gentleman from his peers. In Mary Pix's 1703 play, *The Different Widows*, the inexperienced but aspirational Squire Gaylove finds his new wig so large that, 'I shall neither see nor hear … I can't find my way without being led, 'tis as much too big as a riding coat, and as heavy as a bee-hive … the hairs are all in my mouth'.

The consequently complicated, time-consuming process of getting dressed (and undressed) became, in fact, another opportunity for showing off and for displaying your sophistication. The French 'levee', imported to the English Court by Charles II, turned the business of simply 'getting up' into a full-scale theatrical performance. Each of the King's personal servants had a role to fulfil: the Gentleman of the Bedchamber put on his shirt, the Master of the

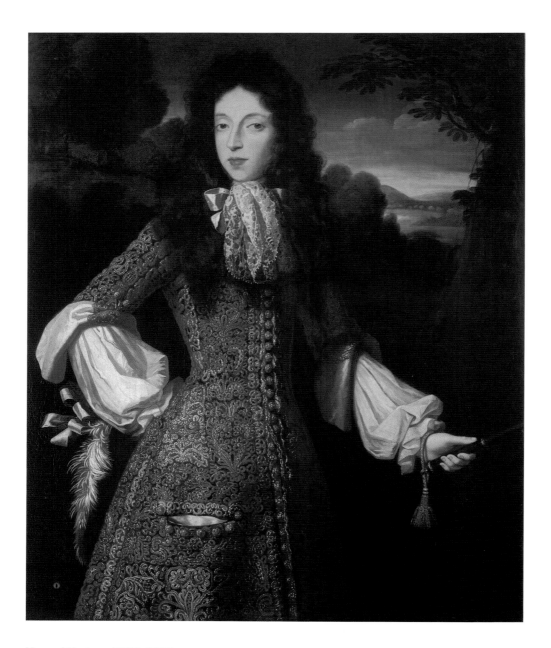

Mary of Modena (1658–1718)

(Simon Verelst, *c*1675–9)

One of the 17th-century fashion trends saw aristocratic women embracing male figure-hugging hunting costumes. This was a self-aware sexualised piece of cross-dressing, which James, Duke of York, 'particular admired' when adopted by his much younger second wife, Mary of Modena.

Robes dressed him in his suit and the Barber shaved him and put on his wig, all in front of a select number of courtiers who gathered in his bedchamber. On account of this, considerable sums were expended on the accoutrements of royal dressing tables. When James II rose each morning, he seated himself at a dressing table decorated with a rich cover of silk, lace and embroideries, made to match his silk dressing gown and slippers.

The levee was also practised by some of the more daring Court ladies, including Charles II's mistress Louise de Kéroualle, who admitted both men and women into her dressing room. On one occasion, Evelyn was among the privileged few who were allowed to follow Charles 'into the Duchess of Portsmouth's dressing-room, within her bed-chamber' at Whitehall Palace. There he saw her 'in her loose morning garment, her maids combing her [hair], newly out of her bed, his Majesty and the gallants standing about her'. This was a beauty ritual, a seductive piece of performance art, with Louise's alluring sexuality at centre-stage, framed by the luxuriously expensive furnishings of her palace apartment.

The largest choreographed performances of all, however, were the spectacular masques, theatrical ballets and musical galas, often to celebrate special occasions, like royal marriages and births, or to mark the visit of an important foreign embassy. These were the grandiloquent testaments to royal swank and authority that defined the Stuart era. Even during the more restrained atmosphere of the early 1700s, there were still birthdays to celebrate and war heroes to fête, where peacock aristocrats could dance with the idealised objects of their desire, and when Admiral Russell could host a party where guests were served by a small boy rowing around an immense bowl full of punch!

'Old Pretender' doll (c1680)
'Five hours, (and who can do it less in?)
By haughty Celia spent in dressing;
The goddess from her chamber issues,
Arrayed in lace, brocades, and tissues.'
(Jonathan Swift, *The Lady's Dressing Room*, 1732)

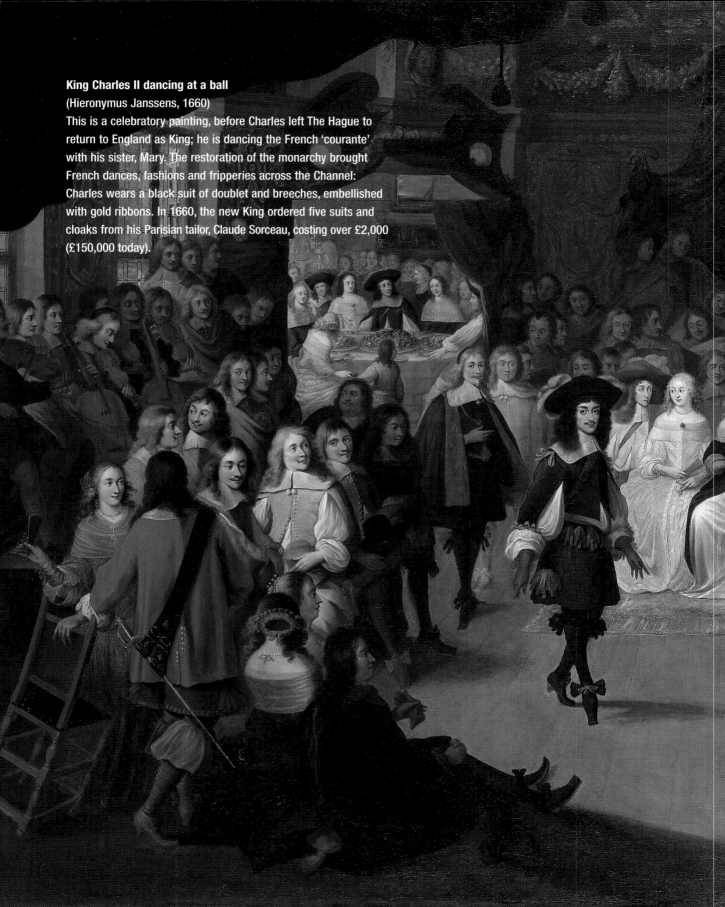

King Charles II dancing at a ball
(Hieronymus Janssens, 1660)
This is a celebratory painting, before Charles left The Hague to return to England as King; he is dancing the French 'courante' with his sister, Mary. The restoration of the monarchy brought French dances, fashions and fripperies across the Channel: Charles wears a black suit of doublet and breeches, embellished with gold ribbons. In 1660, the new King ordered five suits and cloaks from his Parisian tailor, Claude Sorceau, costing over £2,000 (£150,000 today).

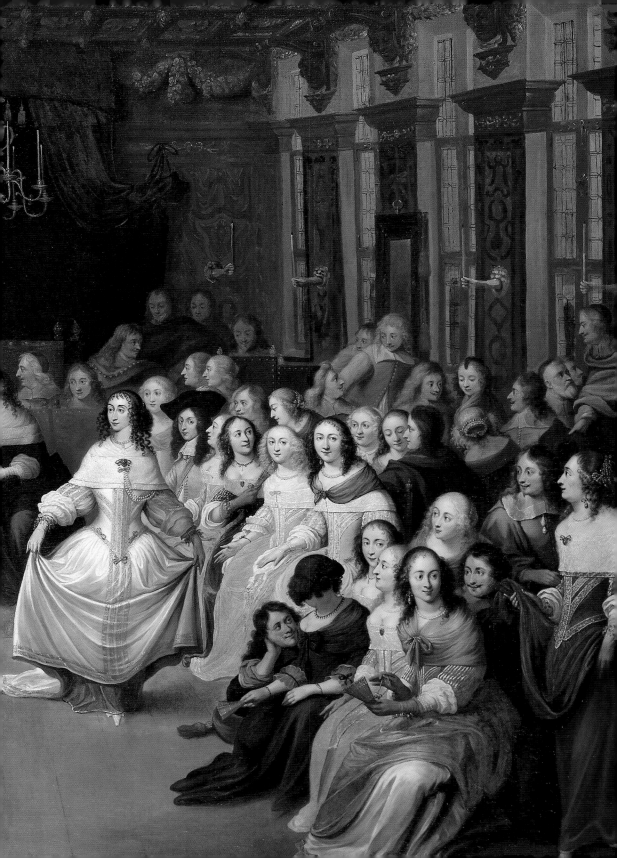

New Additions

UNTO

YOUTHS BEHAVIOUR,

1652. Of some Letters.

As also,

A Discourse upon some Innovations of Habits, and Dressings; Against powdring of hair, Naked-Breasts, Black Spots, and other unseemly Customes.

London, Printed for *W. Lee*, and are to be sold at the signe of the *Turks-head* in *Fleet-street*, neer *Ram*-Alley. 1652.

New Additions unto Youths Behaviour
(Francis Hawkins, 1652)
This was one of the many books that
argued against the idolatry and
sinfulness of face-painting and other
wicked transformations of natural 'virtuous'
beauty into deceitful 'vicious' beauty.

For 'tis vain to think to guess
At women by appearances:
That paint and patch their imperfections
Of intellectual complexions
And dawb their tempers o'er with washes
As artificial as their faces;
Wear, under visor-masks, their talents
And mother-wits, before their gallants;
Until they're hamper'd in the noose,
Too fast to dream of breaking loose:
When all the flaws they strove to hide
Are made unready, with the bride.
(Samuel Butler, *Hudibras*, 1663–78)

Chapter 5

BEAUTY SECRETS

Being beautiful meant wearing the latest fashions, acting gracefully and performing on the daily stage of Court life, from dawn to dusk (and often well into the night!). It was an immense undertaking to keep up the pace, for not only could beauty gain you access to high society, but it was also a perpetual requirement for your continued membership. To keep the party going, men and women were expected to be immutably beautiful: this was, of course, impossible. Assistance was required, and the Stuart courtier had an arsenal of powders, paints and cosmetic tricks to maintain the illusion.

Following French and earlier English fashions, women and men applied copious amounts of make-up to the face. Unblemished skin was a rarity at this period but every attempt was made to acquire and preserve a pure, pale complexion. On their arrival from sun-kissed Portugal, Catherine of Braganza and her ladies were not considered to be attractive as their skin was so dark,

Frances Jennings (*c*1647–1730), as Flora

(Henri Gascar, *c*1679)
'La Belle Jennings' (elder sister to Sarah), whose complexion Anthony Hamilton described as 'more dazzling fair than had ever yet been seen', became yet another mistress of James, Duke of York. She employed the latest cosmetic tricks to help her cause, just as she embraced mythological symbolism in her portraiture (here she is as the Roman goddess of spring): both forms of 'face-painting' were closely related.

as Evelyn chauvinistically remarked, 'The Queen arrived with a train of Portuguese ladies … their complexions olivarder [olive-coloured] and sufficiently unagreeable'. English beauties, in contrast, applied a pale powder of white lead to blanch their faces and coloured their cheeks and lips with Spanish leather or 'paper rouge' (a piece of scarlet leather or paper that dyed the skin on application). The resulting make-up was often so thick that 'a man might easily cut off a curd or cheese cake from either of [the] cheeks'.

Blemishes, spots or pockmarks were covered with patches: small pieces of velvet, leather or paper cut into an array of different shapes such as stars and moons. 'Plumpers', 'much used by old Court Countesses', were also inserted into the mouth to plump up sagging cheeks. In a period when washing the body was unfashionable and even thought dangerous, both men and women used liberal amounts of perfume to mask unpleasant body odours; civet, ambergris and musk formed the basic ingredients, supplemented commonly by sandalwood, aloes, rose and cloves. Queen Mary II's personal accounts reveal that she bought 'Hungary water', a very popular perfume made with alcohol, rosemary, cedar and turpentine; this was used as a body rub, or used on clothes and sponges that were then worn on the body.

Queen Mary II's patch box (*c*1694)
'Ah! Where is all that love and
fondness fled?
Ah! Where is all that tender
sweetness laid?
To dust must all that heav'n of
beauty come!
And must Pastora moulder in the tomb!'
(William Congreve, *The Mourning Muse
of Alexis*, 1695, on the death of Mary)

Until the end of the 17th century, most women used home-made herbal beauty creams, relying on traditional recipes and experimenting with flower, fruit and animal extracts. Recipe books survive that detail a list of commonplace beauty products, with familiar ingredients (olive oil, pine kernels, honey, rose-water, orange-peel and jasmine powder) along with the strange and slightly terrifying (dried bees, pigeon dung, snail ash, opium, hog's grease and urine). Instructions for use varied from the straightforward and sensible ('Take parsley-seed and nettle-seed, the kernels of peaches, boil them together, and with that water wash your face') to the bizarre ('To give colour to a pallid complexion, [rub] the face with a piece of mutton; it will make the skin of a scarlet dye').

There were medications to make hair grow, to remove unwanted hair, to dye it black or blonde, to cure split ends, and to make it shiny; there were other concoctions for smelly feet, bad breath, swollen eyes, acne, greasy skin and even a potion that could tell you whether a girl was a virgin ('Take marble in powder, and make her drink it in wine, if she be deflowered she will vomit immediately'). According to Mary Evelyn's *The Ladies Dressing-Room Unlock'd*, puppy dog fat (from roast puppy presumably!) was used to prepare a cleansing water for the face. At night, women wore gloves made from chicken skin or the skin of unborn calves, lined with cream or a concoction of almond paste, ox gall and egg yolk to keep their hands plump, white and soft.

Gradually, beauty experts began to appear in shops, advertising their 'unique' tonics, powders and creams as solutions to common ailments and problems. Their claims sound very modern, emphasising a product's exclusivity and reliability, with a bit of pseudoscientific jargon thrown in for good measure. The maker of one beauty product, 'Princesses Powder', boasted that 'four Princesses whose beauty is so much talked about in Europe, are served with it, with so great success'; the powder would 'take away all redness, pimples and freckles, and generally all ill things that occur in the face, making the skin as fine, smooth and delicate as satin', which would 'preserve beauty with an air of youth till seventy years of age'. Another whispered that of her particular face-wash, 'neither hath any person the secret but myself, having (with much difficulty) obtained it of a great Lady at Paris, which is now dead'; there was even the promise of 'No Cure, No Fee!'

'The Famous Water of Talc and Pearl'
(1670)

Advertisements for beauty treatments promised much and emphasised their revolutionary new powers, 'never the like prepared in England'. Others offered barely concealed guarantees that their application would lead to sexual success: 'Wash your breasts with warm white wine and rosewater ... by this means you will find them reduced to a small round plumpness, like two ivory globes or little worlds of beauty, wherein love may found his empire ... dart warm desires into his soul, to make him melt and languish before the soft temptation'.

All of this conspired to weigh down the average aristocratic dressing table with a vast array of bottles and boxes, potions and pastes, as frequently listed in the literature of the day:

> A new scene to us next presents,
> The Dressing-Room and implements
> Of toilet plate, Gilt and Emboss'd
> And several other things of cost,
> The table mirror, one glue pot,
> One for pomatum, and what not?
> Of washes, unguents and cosmetics.
> A pair of silver candlesticks;
> Snuffers and snuff-dish, boxes more
> For powders, patches, waters store ...
> (Mary Evelyn, *The Ladies Dressing-Room Unlock'd*, 1690)

'The Complete Beau', from *An Essay in Defence of the Female Sex*
(Mary Astell, 1696)
Men who tried too hard were ridiculed for their vanity and affectations. The 'beau' spent all morning in front of the dressing room mirror:

'His looks and gestures are his constant lesson, and his glass is the oracle that resolves all his mighty doubts and scruples ... When his eyes are set to a languishing air, his motions all prepar'd according to art, his wig and his coat abundantly powder'd, his gloves essenc'd, and his handkerchief perfum'd and all the rest of his bravery rightly adjusted, the greatest part of the day ... is over.'

Arnold van Keppel (*c*1670–1718)
(Godfrey Kneller, *c*1700)
While others were suspected of using their beauty for unscrupulous purposes, Arnold van Keppel, the Earl of Albemarle, was accused of being a homosexual predator who seduced William III to further his own ambitions.

Not everything worked the way it was supposed to; 17th- and 18th-century cosmetics were crude and prone to melt in the heat of a crowded salon. During the celebrations at Hampton Court following Charles II's marriage to Catherine of Braganza in June 1662, the King and Queen dined in public but the 'hall was so full of people and it was so hot that the sweat ran off everybody's face; the Queen's make-up was about to run off with the sweat, so she hurriedly withdrew with the King, and with that, had hardly anything to eat'.

Men and women were ridiculed for becoming narcissistic slaves to their own vanities, often in spite of the raw material at their disposal. George Etherege's 1676 play, *The Man of Mode*, described the failures of the dull pretender to fashion, the self-admiring 'coxcomb' Sir Fopling Flutter, in his search for amorous

adventures, whilst in the same play, Etherege's Harriet complains, 'That women should set up for beauty as much in spite of nature, as some men have done for wit'. Sir Fopling's more successful rival, the urbane and cynical Mr Dorimant, was allegedly modelled on Etherege's friend, John Wilmot, the Earl of Rochester. Wilmot mocked the hysterical demand for beauty products, disguising himself as the 'noble mountebank' Doctor Alexander Bendo, and advertising his services to the vain and gullible:

> I will therefore give you such remedies, that without destroying your complexion (as most of your paints and daubing do) shall render them purely fair, cleaning and preserving them from all spots, freckles, heats and pimples ... I will also cleanse and preserve your teeth, white and round as pearls, fastening them that are loose; your gums shall be kept entire and red as coral, your lips of the same colour, and soft as you could wish your lawful kisses.

Just for good measure, Dr Bendo also promised to interpret dreams and make astrological predictions.

Indeed, while recipe books (compiled by men and women) and advertisements for beauty products frequently extolled their health-giving properties, some treatments were far from restorative. Poisonous ingredients abounded: belladonna (or deadly nightshade) was used to add lustre to the eyes, whilst mercury was commonly used in treatments for just about anything. Lady Frances Catchmay had a recipe for 'mercury water', which would 'kill all heat' and 'make your face much fairer and smoother'. However, mercury could kill more than just heat and pimples: in 1686, the courtier Henry Savile recorded that Lady Henrietta Wentworth (erstwhile mistress of James, Duke of Monmouth) 'sacrificed her life to beauty, by painting so beyond measure that the mercury got into her nerves and killed her'.

Writers since the Renaissance had warned women about the ill effects of cosmetics. A Mr Fierovant, a 'doctor of Physicke', wrote an exposé on the disfiguring ingredients used in make-up: of the 'white lead which women use to better their complexion', he warned, the mixture of lead and vinegar 'is naturally a great drier ... so that those women who use it about their faces, do quickly become withered and gray headed'. He also counselled that mercury was malignant and corrosive: 'such women as use it

Frances Whitmore (*c*1664–94)★

(Godfrey Kneller, *c*1691)
The beautiful life, for some, was over all too soon. Child mortality rates were high (one in five children died before they were ten). Frances Whitmore, one of Kneller's 'Hampton Court Beauties', married Sir Richard Middleton (as her second husband) in 1685; she died in childbirth, aged around 28.

about their face have always black teeth, standing far out of their gums like a Spanish mule, an offensive breath, with a face half-scorched, and an unclean complexion … so that simple women, thinking to grow more beautiful, become disfigured, hastening old age before the[ir] time'.

The art of cosmetics was intertwined with the less than perfect science of early modern medicine. Pharmacists, then as now, sold beauty products alongside medicinal prescriptions. Best-selling

Princess Anne

(William Wissing, *c*1683)

Wissing had his own way of bringing colour to the cheeks of his sitters. According to the critic Bainbrigg Buckeridge in 1706, 'When any lady came to see him, whose complexion was any ways pale, he would commonly take her by the hand, and dance her about the room, till she became warmer, by which means he heightened her natural beauty, and made her fit to be represented by his hand.'

books like George Hartman's *Family Physician* (1696) contained recipes for both, and quack doctors advertised miraculous panaceas that would cure scurvy, consumptions, blood disorders and barrenness. Frequently the cure could be worse than the disease. While medical advances were made during the 17th century, an understanding of the body and how to treat it remained limited; often the methods used on patients, such as bloodletting and purging, exacerbated rather than alleviated complaints.

There was simply no effective treatment for some of the more common infectious diseases of the day. Epidemics, like the 'Great Plague' of 1665, killed thousands, while the libertarian lifestyle came with other, more particular, risks: sexually transmitted diseases were rife, and syphilis coursed through the aristocracy and the whore-houses of London with equal ruthlessness. As George Savile, Viscount (later Marquess of) Halifax, wrote to Wilmot after the agonising death of Jane Roberts (a mistress the latter had apparently shared with the King), mercury treatments were 'so far beyond description or belief' that they would 'make a damned soul fall a-laughing at his lesser pains'. Mary II, meanwhile, died in 1694 of smallpox, one of the biggest killers of the day, while those that survived an infection were often left with terrible scars. When Frances Stuart was diagnosed, Pepys recorded that she was 'mighty full of small-pox, by which all do conclude that she will be wholly spoiled, which is the greatest instance of the uncertainty of beauty that could be in this age'.

Masks and patches worn by ladies were, often, both a fashionable accessory and a disguise, and everyone was well aware of what could be hidden beneath. Apart from the creative concealment of smallpox scars behind beauty patches, make-up in general was derided as a method of forgery whereby women 'could teach their face to lie, and to show what it is not'. A male correspondent to *The Spectator* of April 1711 complained that he had been tricked into marrying a 'Pict' (a painted lady) whose beauty was 'all the effects of art'. By their own 'industry', he warns, women 'will make bosom, lips, cheeks and eyebrows'. The use of rouge was especially deceitful. A natural blush was prized as a sign of feminine sensibility and virtue, while the absence of a blush signified lost modesty and worldliness; an artificial blush confounded this, making it impossible to distinguish between an innocent and a sinful woman.

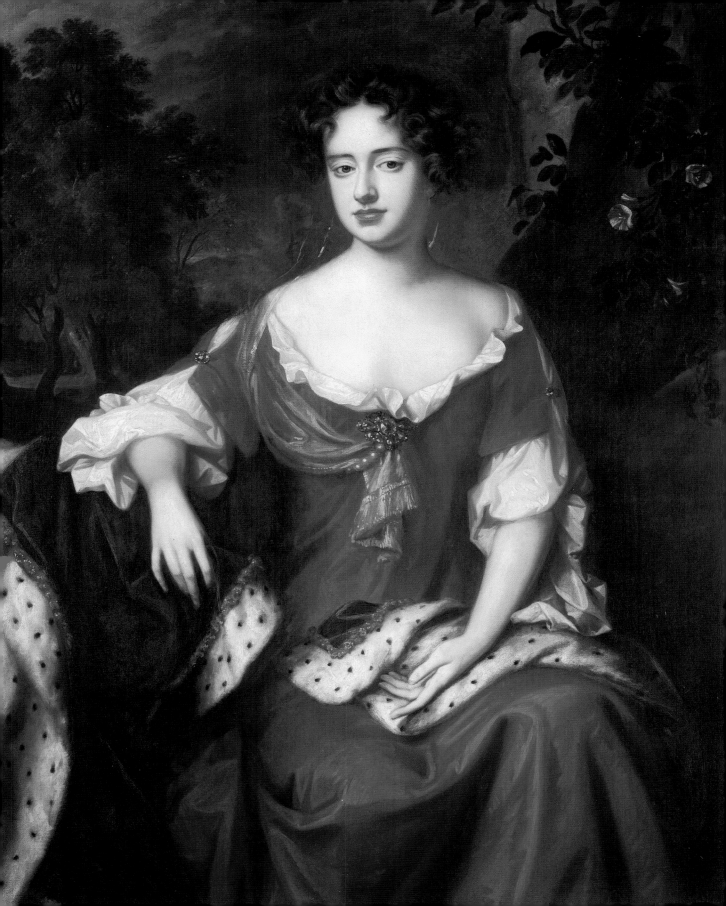

'La Femme Coquette'

(Fashion plate, 1697)

Wary men mistrusted women who, they thought, conspired to use beauty to ensnare lovers, as John Wilmot described the purpose of Louise de Kéroualle's beauty regime: 'To varnish and smooth o'er those graces, You rubb'd off in your night embraces: To set your hair, your eyes and teeth, And all those powers you conquer with.'

Moralisers were accordingly quick to link make-up and cosmetics with sexual promiscuity and impiety, and implored men 'always to examine into what they admire'. Just as natural beauty indicated a virtuous soul, artificial beauty indicated a corrupted one: 'spotted [patched] faces have but spotted souls'. Indeed, masks fell out of fashion in the early 1700s because they became more commonly the mark of a prostitute. Face-painting was cast as a form of idolatry, a self-love that replaced a proper appreciation of God's own handiwork. Fashionable ladies, it was argued, spent too much time at beautifying themselves, privileging surface over substance. As George Savile wrote in 1688 in the *Lady's New Years Gift: Or Advice to a Daughter*, 'The looking glass in the morning dictateth to her all the motions of the day, which by how much the more studied, are so much the more mistaken'.

The difference between 'natural' and 'artificial' beauty was, however, culturally and sexually defined. The outspoken writer and philosopher Margaret Cavendish, Duchess of Newcastle, questioned why it was thought artificial to use cosmetics but natural, if you were a man, to cut your hair, shave your beard or wash your face. The real issue, it seems, was that the privacy of the dressing room, and the secrecy of a lady's beauty toilet, threatened the authority and dominion of men. On the other hand, there were some more enlightened men who leapt to the defence of cosmetics because their application empowered women to develop their own skills, take possession of their own image, and to navigate the world with confidence. Too often, however, such arguments resorted to a hackneyed reflection of the realities of a male-ordered society that – ultimately – women should make themselves as attractive as possible, for their husband's sexual pleasure:

> God the author of all things, to make Man in love with his wife, in her state of innocency, he made her smooth, soft, delicate and fair, to entice him to embrace her; I therefore, that women might be pleasing to their husbands, and that they might not be offended at their deformities, and turn into other womens' chambers, do commend unto you the virtue of an eminent and highly approved balsamic essence, with several other incomparable cosmetics.
> (Anonymous, 17th-century advertisement)

Hortense Mancini (1645–99), with her sister, Marie (1639–1715) (Jacob-Ferdinand Voet, *c*1660–75) Hortense, Duchesse Mazarin, was, according to Anthony Hamilton, simply 'the most beautiful woman I have ever seen'. In this portrait, her sister Marie reading Hortense's palm, predicts that she will marry a young and gallant king. Hortense did, briefly, become the mistress of Charles II, but the affair was short-lived.

Gender stereotypes encouraged the perception that the female sex was expert in the art of trickery and deception. As Dorimant in Etherege's *The Man of Mode* remarked, there 'is an inbred falsehood in women which inclined 'em still to them whom they most easily deceive'. There was a misogynistic concern that the arts of beauty actually empowered women (who became 'art-ful beauties') to act as subversive agents of social revolution. Beautiful women could deceive, cheat and conquer men, thereby upturning 'natural' gender relationships. Women 'will wanton and play with the signs of their eyes, head, hands, gloves, handkerchiefs … with these inventions and artifices they steal away the heart, and blind the spirit of the idolaters of their vanity'.

When the sensational Hortense Mancini, Duchesse Mazarin, arrived at the English Court in 1676 on the run from her husband, her reputation preceded her. There were stories of adventurous escapes and exotic love affairs (with men and women), all retold by men with prurient interest but also in fear that such a man-eating social revolutionary might encourage other women to follow her example. Hortense herself, however, was in no doubt that she had been more the victim of circumstance (and a mad husband) as the heroine of her own narrative. Her 'wild' actions were seen as dishonourable simply because they were viewed through a chauvinistic lens. She may have been portrayed in paint as a latter-day Cleopatra, but, in truth, women were far less in command

Elizabeth Butler (1640–65)

(Peter Lely, *c*1660)

Lely depicted Elizabeth as a youthful bride, aged 20, delighting in her natural, unadorned beauty (there is no gaudy necklace to corrupt her perfect skin). 'One of the most charming women whom you could find anywhere,' wrote Anthony Hamilton, 'she had an enchanting figure ... she possessed the radiance and whiteness of skin which goes with fair women, enhanced by all the liveliness and piquancy which is peculiar to those who are dark ... her regard [was] extraordinarily seductive.'

of their own destinies as this allusion implied: 'I know that the honour of a woman consists in never being talked about ... but one cannot always choose to live the kind of life one would want to lead.' Even Cleopatra was ultimately helpless in the face of male military power.

Barbara Villiers, meanwhile, was reviled by courtiers (and the general public) as much as she was revered: a controversial celebrity of whom everyone had an opinion. Count Lorenzo Magalotti, a visiting Italian diplomat, considered that, 'not only in her carriage, but in every gesture of the arms and hands, in every expression of her face, in every glance, in every movement of her mouth, in every word, one recognizes shamelessness and whoredom'. This view was informed by knowledge of Barbara's amorous curriculum vitae; for others, the distinction was not so easy. As William Wycherley (himself a lover of the prodigious Duchess) maintained in his 1676 prologue to *The Plain Dealer*, 'You can no more know a kept wench from a woman of honour by her looks than by her dress'. If Nell Gwyn, meanwhile, could navigate her way from orange-selling whore to royal courtesan, then there was also the fear of unbridled social anarchy. Access to affordable beauty products allowed a woman of questionable moral compass to ensnare a rich man and acquire the accoutrements of upper-class society: costly clothes and jewellery had the power to erase the distinctions of birth, confounding notions of class identity.

Beneath these general fears of social and sexual revolution, there were some personal, and timeless, reactions to the power of beauty, and some very particular victims. Beauty was the cause of jealousy and rivalries that could prove fatal. Elizabeth Butler became the Countess of Chesterfield on her marriage to Philip Stanhope in 1660. At Court, she attracted the attention of the Duke of York. Her husband (the erstwhile lover of Barbara Villiers) packed her off into the country, her beauty enough to condemn her to exile. Within a year, she was dead, poisoned, it was rumoured, by Stanhope. An affair between Anna Maria Talbot, Countess of Shrewsbury, and George Villiers, Duke of Buckingham, occasioned a duel between the Duke and Anna Maria's husband. As Pepys recorded, 'My Lord Shrewsbury is run through the body, from the right breast through the shoulder [he died a month later from his wounds] ...This will make the world think that the King hath good counsellors about him, when the

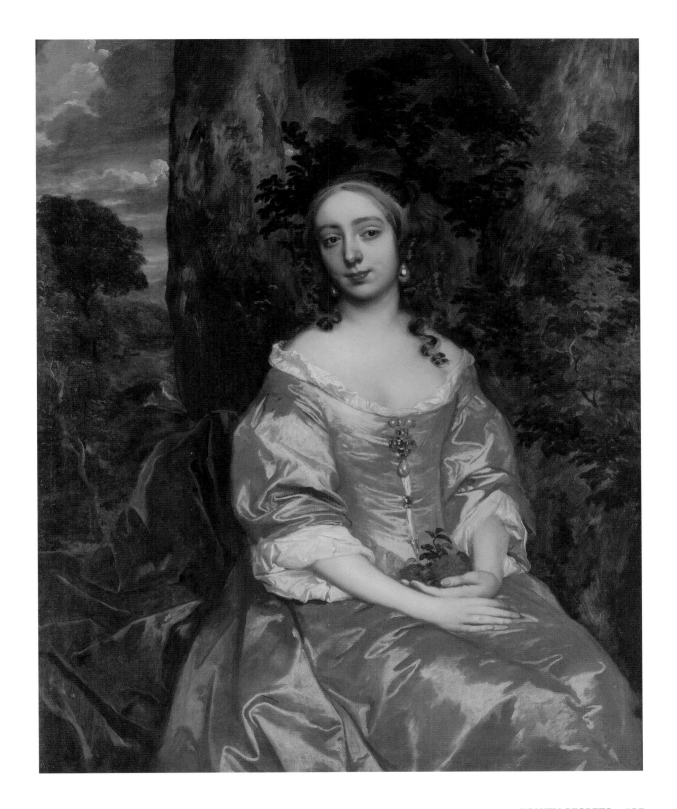

Duke of Buckingham … is a fellow of no more sobriety than to fight about a whore.'

There is a misanthropic edge to many of the prurient descriptions of women in the late 17th century. The old double standards are at work. Pepys, Evelyn and their contemporaries were, to different degrees, racked with self-loathing and Puritanical guilt whenever they delighted in the beauty of a woman, and were quick to pass on the blame to the object of their desires. Wilmot's vitriol, naturally, spared no one, least of all the royal concubines. In his 1670s poem *Portsmouth's Looking Glass*, he described Louise de Kéroualle thus:

> Methinks I see you newly risen
> From your embroider'd bed and pissing,
> With studied mien, and much grimace
> Present yourself before your glass …
> Lay trains of love, and state-intrigues,
> In powders, trimmings and curl'd wigs:
> And nicely choose, and neatly spread,
> Upon your cheeks the best French red.

Rather than the symbol of virtue, beauty could be a metaphor for all that was impure and incurably vicious. Beauty was the cause of Man's fall from grace, and therefore Man delighted when beauty in turn was stripped of its pretensions and punished for its rapacity and ambition:

> The soot or powder which was wont
> To make her hair look black as jet,
> Fall from her tresses on her front,
> A mingled mass of dirt and sweat.
> Three colours, black and red and white,
> So graceful in their proper place,
> Remove them to a different light,
> They form a frightful hideous face
> But, Art no longer can prevail
> When the materials all are gone,
> The best mechanic hand must fail
> Where nothing's left to work upon.
> (Jonathan Swift, *The Progress of Beauty*, 1719)

Anna Maria Brudenell (1642–1702)

(Peter Lely, *c*1665–8)

Anna Maria's crime was to be beautiful and to attract the attentions of older, lascivious men. Anthony Hamilton claimed that 'a man might be killed for her every day, and she would hold up her head the higher on account of it'. Villiers, Duke of Buckingham, was described by the poet Samuel Butler as 'diseased and crazy ... continual wine, women and music ... debauch his understanding'. Anna Maria moved in with Buckingham after the death of her husband.

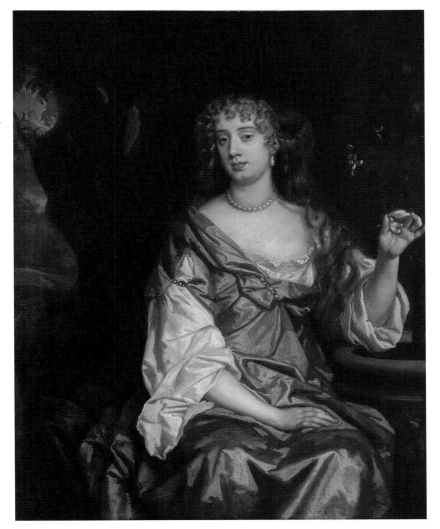

It was still a man's world. Even Margaret Cavendish, 'ambitious as ever any of my sex was, is, or can be', was forced to invent a work of fiction, *The Blazing World* (1666), to promote a more equable future for women. There were limits to beauty, just as there were limits to what women could hope to achieve in society. Perhaps every woman hoped for the opportunity to promote her attractiveness, but for many their chances were severely restricted. The elite and the Court were a world apart from the general experience.

WOMEN, WORK AND BEAUTY: THE WORLD BEYOND THE COURT

Chapter 6

The cult of 'Beauty', revealing diaphanous costumes, the arts and wiles of the dressmaker and the make-up artist, bed-hopping, debauched lives and bastard children. This is the later 17th-century world conjured up in this book.

It begs a question: was this what the real world was like, beyond the Court and its ways? Released from the savagery of Civil War and the strictures of puritan rule, did the nation follow its leaders pell-mell down the path of dalliance? Were these women with their relaxed social and sexual mores the role models for the female sex in England to follow? The short answer is 'no'.

In some ways, the experience of most women was quite contrary to what was happening among the elite and at Court. Yet this was also an age when many women were better able to express themselves, could lead independent economic lives more easily, and were consumers of finer things and beauty aids on an unprecedented scale.

Susan Gill

(Charles Beale, 1680)
Beale's sketchbook contains this portrait of the household's servant girl, Susan Gill, who like many had come to London to seek work and opportunity. Jane Birch, the maid in Samuel Pepys's household who features often in his diary, would probably have been like her: sweet, meek and incredibly hard-working.

The picture is nuanced, different from decade to decade and place to place, but there is a consistent pattern that makes the 50 or so years after 1660 one of the most interesting, exciting and formative eras in the past for the rights and lives of women. Many more prospered and took advantage of structural change in the economy and in the population at large. The foundations were laid for the great economic explosion in the century that followed.

Pins, paper, lace, velvets and coffee all played their part. So did the economic instrumentality of women, especially women living in towns, and the ages at which they married and their childbearing histories.

Let us start with sex and marriage. We know from the world of the Court that the years after 1660 were an era of licence and sometimes debauchery. The Merry Monarch presided over a raunchy Court life. Bastardy was not uncommon and the descendants of the King's bastards form the bedrock of the senior aristocracy to this day. It is here that the wider picture is probably most different.

The population of England had experienced probably unprecedented growth for about a century by the 1640s, the decade in which Civil War broke out. The number of people in England had almost doubled to 5.5 million. The strains this placed upon society were enormous, in terms of poverty, susceptibility to food shortages and depressed real wages. Periodic outbreaks of bubonic plague devastated city populations for a short period, but the bounce-back was usually swift. London, by far the greatest English city, increased in size from 50,000 to around 275,000. While other towns and cities had grown, none could begin to match the metropolis. In the countryside, people were forced to exploit the margins. Something had to give.

It did give. Population growth came to a shuddering halt. The total English population fell back to 5 million by the 1670s, recovering to 5.6 million again only in the 1740s.

The principal motor for this change was marriage and fertility. Elite marriages often took place at earlier ages with women in their teens, as money, family standing, titles and property were at stake. Many marriages were remarriages for widowed men and the age disparity between partners could be considerable. In the world at large, however, men and women had already been marrying quite late, on average in their mid-20s. Now they were delaying marriage further still, into their later 20s. This had the

'Couple with cupid'

(Pepys Ballads vol.III, no.138 *c*1680)
Samuel Pepys was famed for his diary; he was also a public official and an assiduous book collector. His library contained not only expensive texts but also printed ephemera, the widely circulated ballads and chapbooks sold by peddlers. These offer a rare glimpse into the world, prejudices and humour of ordinary people.

'Rocke the cradle, Joan'

(Pepys Ballads, vol.I, no.397, *c*1680)
A husband instructs his wife, as she consents to take his illegitimate child as her own. The interior, clothes and furnishing suggest a household of some standing; the poor print quality is typical of these cheap publications and the message about bastardy is clear in an age when levels of illegitimacy were at a historical low.

'Courting couple'

(Pepys Ballads, vol.IV, no.119, *c*1680)
This couple is shown in an idealised and romanticised light. The reality was usually different – and, for many, marriage was less likely to be an option given the relative scarcity of available partners.

'An Exact Delineation of the Famous City of Bristol and Suburbs'
(Publisher James Millerd, 1673)
In this very detailed map of Bristol published in the 1670s, the inner areas of the city are shown as closely built networks of streets and courts. Despite the central role of the wharves and port trade, many more of the inhabitants were women rather than men, a feature common to most urban areas in the second half of the 17th century.

effect of reducing the number of children a woman could expect to have in her lifetime: six or seven, perhaps, of whom two or three might die in infancy or childhood.

It is not as if people were expressing their sexual frustrations outside or before marriage either. In spite of the reputation of the Court of Charles II, the second half of the 17th century witnessed the *lowest* ever recorded levels of illegitimacy in England. Whereas in earlier decades, in some communities one baby in 15 may have been born a bastard, during these decades it was often one in 50 or one in a hundred. The rector of Great Cheverell, a village on the Hampshire–Wiltshire border, proudly recorded in 1713 that in his little corner of paradise, the young men 'seldom drink to excess or are guilty of other debaucheries. And one thing here is remarkable, that for the space of forty years past and upwards no illegitimate offspring have been in this parish.' It was a record that was in fact not unique (the drinking apart). The temperate philosophy, imposed by the spiritual gatekeepers of Cromwell's Protectorate on a God-fearing population – the lock placed upon sexuality and fertility – was a ferociously strong one.

How was this remarkable turnaround achieved? Nobody quite knows; but there are pointers. Low real wages due to high fertility and too many people in one period were followed by low fertility but, with fewer people competing for work, higher real wages in another.

More importantly, men and women may actually have had fewer chances to find a partner. One of the reasons that marriage was usually late was that teenagers and young adults commonly left home for a number of years to live as servants in other households. Few were like the footmen and maids of Victorian households. They did farm work, domestic work, or they assisted shopkeepers, tradesmen and craftsmen, and they moved around, usually once a year. They married and set up households only when they were ready to take root permanently. It was an ancient way of life that survived until the Victorian age, but it seems to have been strongest at this period.

This was also an age of rapid urban growth. Towns and cities were consumers of people; more died than were born there, and numbers were sustained through continued migration. Many moved into towns from the countryside; urban populations were increasing fast. The metropolitan population doubled to over half a million by the close of the century, against the backdrop of

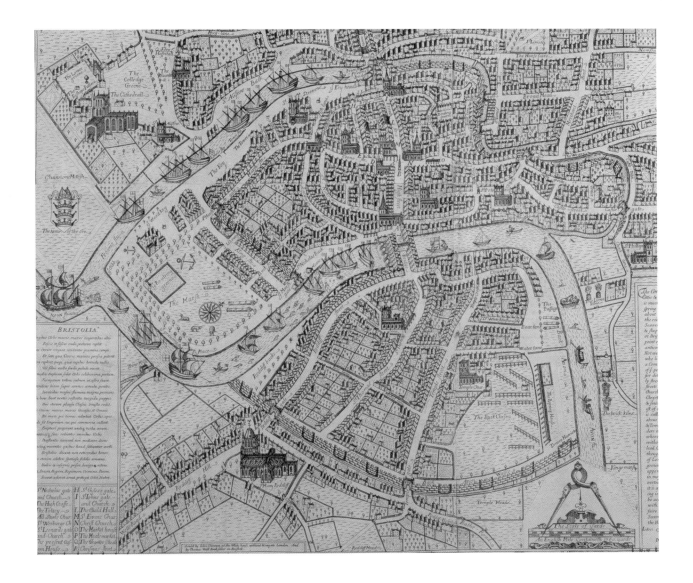

essentially stagnant numbers in the country at large, and most provincial towns and cities had similar experiences. In fact, many towns grew at a faster pace still. Half of all surviving infants in late 17th-century England would find themselves fuelling the unstoppable growth of London, and by this time more of these migrants were girls than boys.

Some evidence for more women moving to towns than men comes from strange origins. King William III resorted to many different expedients to raise money to fight his wars against

'Two women'

(Pepys Ballads, vol.III, no.290, *c*1680)
The chatting women wear fashionable clothes, mantuas and elaborate lace headdresses. As the text itself makes clear, 'Sweet-faced Jenny' is telling her mother that she intends to quit her spinning wheel and go to town to enter 'a more pleasant employment'. Her ambition is to become a prostitute, one of the many potentially lucrative occupations open to her.

Louis XIV and France. One of the most ingenious was the so-called Marriage Duty Act of 1695, a tax on all births, marriages and deaths, with a levy on wealthier widowers and on bachelors over the age of 25. In some places, especially towns, censuses were taken to track payment of the tax. Where these survive – and many do – they provide a rare glimpse into that place and time.

In Bristol, to take one example, the whole city was recorded in 1696. In wealthier inner city parishes, there were 72 males for every 100 females, and many were servants; poorer parishes had 80 or 90 males for every 100 females, with fewer servants. People often lived alone or in subdivided properties and many of those too were women. Some, like Dorothy Woodhouse, a vintner in Bristol High Street, and her near neighbours Hannah Nicholas and Elinor Evans on Bristol Back, had sound victualling businesses. Others were street traders; some took in washing, spun wool, or kept bars and lodging houses. A striking number were unmarried women and widows.

It is a pattern that was repeated in London and in other towns. By contrast, villages often had surplus men. So one reason why people married later, and some never married at all, was a simple shortage of potential partners.

Whether married or not, women were expected to take part in business and the family economy. One Sussex shopkeeper rather unromantically described a wife's virtues as 'conduct, prudence and good economy'. A man had, in theory at least, overall control of his family and household. A woman's property was her husband's. A woman had to belong to somebody, and spinsters and widows often fell outside the recognised social hierarchy simply because they were not dependent upon a man. Countless books and sermons described the ideal household and the supremacy of men. The picture on the ground, however, was less clear-cut.

During this period, the old restrictive controls of the craft guilds were waning in many towns. Households depended on what women could earn as well as men. Any and every local economy has evidence of women selling, knitting, sewing, making, baking, brewing, keeping bars, charging for midwife services, and so on. The evidence also gets stronger as time goes by, suggesting that an increasing number of women were in active work. By the early decades of the 18th century, one in ten of the businesses insured by the Sun Fire Office was being run by women. This

Interior of a London Coffee House (c1700)

A well-dressed woman presides over the near-mayhem of this London coffee house, in an illustration painted around 1700. The fashionable new drink was another example of the burgeoning consumer economy; coffee houses were important places to conduct business and exchange news, and women were integral to the food and drink trades.

may just mean that women were more cautious – but it is also likely that it is a reflection of the changed economic landscape, in which there were many women working and living independently, whether from necessity or choice.

There are two further components in the changes for women in the years after 1660. The first is skill; the second is consumer goods and disposable incomes. Women's voices were rarely heard at this time. Women writers were uncommon and published works by women rarer still. For most women, the only record of their lives was in the registration of baptisms, marriages and funerals. The transcripts of spoken evidence in a courtroom give a sudden, unexpected glimpse into real life before the door closes again. Yet, more women were now able to write, and that underpinned the growth in women's work. At the close of the 16th century, fewer than ten per cent of women could sign their name. As reading was taught before writing, this probably means that a higher proportion could read, but a lower proportion than that

'The Cries of London' (*c*1650–60)

These were popular illustrations in the 17th and 18th centuries, the street sellers and hawkers being a ubiquitous, noisy yet still colourful aspect of urban life. Usually half of the sellers were women, specialising in one particular commodity, whether it be cherries, clay tobacco pipes or handkerchiefs.

could actually write. A century later, the situation was quite different, and now three-quarters of women could sign. Women had almost caught up with men, first in towns, then in the countryside, as they had more access to schools and there were more reasons for them to be able to read and write.

Literacy helped fuel trade; and literacy would open new horizons. The cheap ballads and chapbooks that Pepys collected, still housed in the library that he bequeathed to his Cambridge college, reveal a world of contemporary attitudes, jokes, stories and sorrows. These were printed in their millions and distributed everywhere, often to be sold for a penny by women hawkers and stationers. Ballads were adorned with woodcut images that invited both interest and scorn: images of beautiful, fashionable women with beauty spots on their faces and their breasts exposed were an indicator of urban fashion that could be emulated – or were figures of fun to countrywomen.

'A fashionable woman'

(Pepys Ballads, vol.III, no.80, *c*1680)
With her beauty spots and low-cut
dress, this creature was a figure of
both admiration and derision.

The impact of higher living standards overall was also felt in what people bought – and what was made to satisfy that demand. A contemporary statistician calculated that half of a household's income was spent on food and a quarter on clothing. That bare figure, he worked out, translated into three million hats, 10 million pairs of stockings, 12 million pairs of shoes, eight million pairs of gloves and 10 million shirts a year, mostly ready-made, and many made or sold by women. The foundations of spectacular British industrial growth in the century that followed often lie in simple items such as stockings, pins to keep garments together, or crockery to put on the table. This still equates to 2.2 pairs of shoes per person, barely credible to a modern Englishwoman, but luxury to her late Stuart counterpart.

The consumer power of women was integral to economic change in the late Stuart era, and women were able to spend more time and money on themselves. The higher her social status, the more time and care a woman was likely to spend, but personal attention, health and beauty occupied the minds of many. The making of mantuas – the loose over-gowns popular at the time – was a common woman's occupation, while traditional hat- and gown-making was still largely a man's trade. A beautician in central London at the close of the century could advertise herself as selling 'a most excellent wash to beautify the face ..., its virtue is to take out all manner of wrinkles, freckles, pimples, redness, morphew, sun-burn, yellowness, or any other accident caused too often by mercurial poisonous washes ...'.

Part of that attention came in the form of advice manuals, which were some of the first books for women written by women. This example comes from Hannah Wolley in *The Gentlewoman's Companion* of 1675:

> *An infallible receipt to increase milk in a woman's breasts.* Take chickens and make a broth of them, then add thereunto fennel and parsnip roots, then take the best made butter you can procure, and butter the roots therewith; having done so let her eat heartily, and her expectations therein will be speedily satisfied.

Wolley was born in 1623, and was educated by female relatives and other women. Twice married, she took on a variety of occupations, including matron in the school run by her first

'The Queene-Like Closet' (1670)

In the frontispiece to Hannah Wolley's book *The Queene-Like Closet*, the range of women's household work is depicted. Many of these tasks would have increased in complexity and number as households were able to buy more consumer goods. Wolley herself is portrayed in a separate woodcut illustration.

husband. She published several advice books on health and domestic economy and was a consummate self-promoter. In *The Queene-Like Closet* of 1670 she wrote,

> I have set down everything as plain as I can; and I know there are very many who have done very well by my books only; but you may imagine that if you did learn a little by sight of my doing, you would do much better… Be pleased to offer me some of your money, and I will repay you with my hands and skill. That I judge to be fair on both sides.

First of the domestic goddesses, Wolley was joined by women poets, novelists and playwrights in publishing and promoting themselves. Whereas women writers had been very rare, now they were no longer unusual. Aphra Behn enjoyed huge success on the stage and in print, with plays such as *Abdelazer* (1676) and novels of which the best known is *Oroonoko* (1688). Of her, Virginia Woolf said 'it was she who earned [women] the right to speak their minds.' Behn's 1677 play, *The Rover*, describes the adventures of Helena, a female 'gallante', who pursues and wins her lover by her wit. Helena – Eleanor – was, not coincidentally, the same name as Behn's friend, Nell Gwyn. The Restoration theatre was in itself a new place for women to speak, as actresses were allowed to perform in public for the first time. Some of them, of course, also caught the eye of the King and his courtiers.

A strong connection between newly independent women and the world of Court portraiture came in the shape of Mary Beale. Born in Suffolk in 1632 and a popular artist of the years after 1670, she was the first English female artist of note, at least the first for whom we have a name. She knew and took inspiration from Lely, and ran a successful business in portrait painting in which her husband and son played second fiddle. Her *Discourse of Friendship*, although never published in her lifetime, expressed a particularly feminine approach – Eve was to Adam, she wrote, 'A wife and friend but not a slave; for we find her not in the beginning made subject to Adam, but always of equal honour and dignity with him …' Moreover, 'Friendship is the nearest union which distinct souls are capable of.'

With Mary Beale, we connect back to the world that circulated close to Charles II and James II. We are also in a provincial town, Bury St Edmunds, where polite and less polite society congregated

Mary Beale (1633–99)

(Self-portrait, *c*1673–80)
This is one of Mary's numerous self-portraits. Based in the social centre of the Suffolk town of Bury St Edmunds, hers was one of the busiest provincial portrait-painting businesses in the country.

every year in September for Bury Fair, satirised in Thomas Shadwell's 1689 stage play of that name, with shops and services run by men and women eager to seize the occasion. The inveterate traveller Celia Fiennes, when she came in the 1690s with just a horse and groom as companion, punned, 'It's a very dear place; so much company living in the town makes provision scarce and dear. However, it's a good excuse to raise the reckoning on strangers.'

This helps to sum up the experience in England in these years. Women had greater visibility as traders, manufacturers, writers and consumers. Towns were the economic motor and migrants were their lifeblood. Consumer goods and the service economy were the means for profound economic change. There was far greater wealth in the system and more opportunities for women to express themselves in print as well as in work. The experiences of ordinary women in these years were radically different – often diametrically opposed – to the experiences of women at Court and Lely's and Kneller's subjects for their Beauty paintings. Yet there are connections and parallels, and one could not have happened without the other.

**Dorothy Gish (1898–1968),
as Nell Gwyn**
(*Nell Gwyn*, directed by Herbert Wilcox,
1926)
Nell's longevity as a romantic icon and
heroine of historical fiction owes much
to her modest beginnings, her sense of
humour and her 'cockney' Englishness.
She was, in fact, deeply attached to
Charles II, her lover and protector, as
one of her few surviving letters reveals:
'He was my friend and allowed me to
tell him all my griefs and did like a
friend advise me and told me who was
my friend and who was not.'
 Nell died in 1687, two short years after
her royal lover.

... Beauty's corrupt, and like a Flower stands
To be collected by impure hands.
'Tis hard as 'tis impossible to find
Virtue and Venus both together joyn'd.
For the Fair She, who knows the force and strength
Of Beauty's charms, grows proud, and then at length
Lust and ambition will possess her breast,
Which always will disturb man's peaceful rest.
(Unknown author, *A Satyr on Beauty*, 1679)

Chapter 7

THE DEATH OF BEAUTY

There was no grand, universal sexual revolution between the Restoration of Charles II in 1660 and the death of Queen Anne in 1714. Many women, inside and outside of the Court, had discovered new opportunities and careers, yet their world was still circumscribed by legal and cultural restrictions that defined their very existence as inferior to men. The worship of beauty had not led to female emancipation, but remained, at best, an ambivalent tool: women used it to command a personal influence at the heart of government and the Court, but were themselves chased and abused, pilloried as whores. The unknown author of the stupendously pornographic *Sodom* of about 1668 (dedicated to the 'Royal Company of Whoremasters'), renamed Charles II's principal mistresses as Fuckadilla, Clytoris and Cunticula. The latter's epilogue defines Court beauty as nothing more than a trap, designed to challenge male hegemony and upset the status quo:

Clothe in perfume our alabaster thighs,
And make cunt fit for nose, for lips and eyes.
Thus dress't in charms, you should in crowds resort,
And hourly swive us beauties of the court ...

Many had been persuaded to join the 'beautiful revolution', carried along for a while by the charismatic decadence of Charles II, but the party was over after little more than a decade. Foreign policy failures, Dutch Wars, the plague and the Great Fire of London had instead revealed the political (and, it was argued, sexual) impotence of the King. Most woke up (if they woke up at all) with a hangover and decided that traditional values were best, and that 'Englishness' somehow meant refinement, sobriety and restraint. Baroque taste and extravagance went out of fashion and were replaced by a neo-classical temperance that has, ever since, been the default 'English' style. Social conventions retrenched, outrageous libertarianism was condemned, and the beautiful life parodied as a vanity project.

The Court was also, if not in irreversible decline, financially overstretched and, after 1688, increasingly politically neutered by the newly enfranchised, executive parliament of the 'Glorious Revolution'. At the same time, William III and Mary II created an alternative image of monarchy as a godly Protestant moral enterprise, a union of monarchical virtue. Royal mistresses and misbehaviour continued, ambition and sleaze survived, but never again would such an explicit display of indulgent dissolution be tolerated. In 1698, with an appropriate sense of timing, a great fire swept through Whitehall Palace, destroying, literally and metaphorically, the old world of the Stuart Court.

You can see the change in the portraits by Kneller. His beauties are more upright, less sexually available, arguably more aristocratic, than Lely's. This is a style of portraiture that emphasised and sympathised with the social order, rather than challenging it. In life, as in art, the 'Hampton Court Beauties' *were* less controversial than their predecessors, and the Court they inhabited a less licentious one. Even Carey Fraser – whose long career (she was already in her 30s when painted by Kneller) had begun by scaring away her suitors with her expensive fashion choices, and being touted as a potential mistress for King Charles – settled down to matrimonial modesty as the Countess of Peterborough. William III, meanwhile, apparently took only one

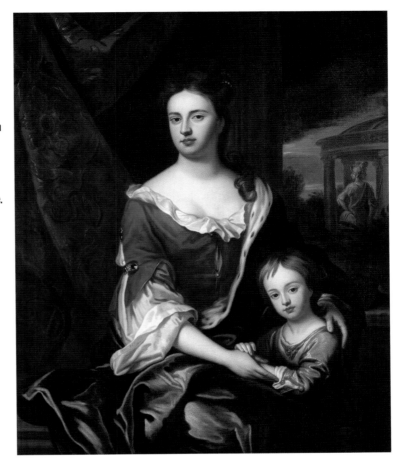

Princess Anne, with her son William, Duke of Gloucester (1689–1700)

(Godfrey Kneller, *c*1694)

Queen Anne had 17 pregnancies, producing 18 children, with only five being born alive. Smallpox swept away two little daughters, within days of each other in 1687; Prince William, born in 1689, succumbed to the same disease a week after his 11th birthday, leaving England without a direct heir to the throne.

mistress throughout his reign – Elizabeth Villiers, the Countess of Orkney, and cousin to the more notorious Barbara. Being women, Queen Mary and Queen Anne were not allowed any of this amorous freedom (although Queen Anne had female favourites to whom she was very close).

Beauty was a transient thing: it could be cut short by death or disease. Even if a woman survived smallpox unscarred, her beauty (it was thought) withered with age. As Dorimant makes clear in Etherege's *The Man of Mode*, 'They pretend to be great critics in beauty ... They cry a woman's past her prime at twenty, decay'd at four and twenty, old and unsufferable at thirty'. Cosmetics were helpless in the face of lost beauty and may in fact have played a part in hastening its destruction. As Jonathan Swift wrote in *The Progress of Beauty* of 1719:

Barbara Villiers
(Copy of a painting by Godfrey Kneller, *c*1700)

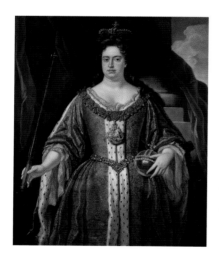

Queen Anne
(Studio of John Closterman, *c*1702)

When mercury her tresses mows,
To think of oil and soot, is vain:
No painting can restore a nose,
Nor will her teeth return again.
Two balls of glass may serve for eyes,
White lead can plaster up a cleft;
But these alas, are poor supplies
If neither cheeks, nor lips be left.

Barbara Villiers refused to accept this and her career as a free-spirited adventuress (or unscrupulous jade) continued into her middle age and beyond. In 1705, aged 65, after the death of her estranged husband, Lord Castlemaine, she was involved in a bigamous intrigue with Beau Feilding, a cupiditous retired army captain. Feilding, in a farcical series of events worthy of a Restoration comedy, had recently married a Mary Wadsworth thinking, mistakenly, that she was a rich widow named Mrs Deleau, and now sought to compound his potential sources of revenue by seducing and marrying Barbara as well. If this was not enough, Feilding then began an affair with Barbara's granddaughter, Charlotte Calvert, who had taken refuge from her own unhappy marriage in her grandmother's Bond Street house. The following year, Barbara confronted Feilding, who threatened her with a gun until help arrived and he was arrested. The marriage was dissolved in 1707; Barbara died two years later.

By this time, Queen Anne was a bloated invalid queen without an heir, racked by arthritis and deformed by gout; confined to a wheelchair, she had to be winched in and out of bed. Her condition was the antithesis of queenly splendour as the visiting Scottish diplomat Sir John Clerk wrote:

On this occasion everything about her was much in the same disorder as about the meanest of her subjects. Her face, which was red and spotted, was rendered something frightful by her negligent dress, and the foot affected was tied up with a poultice and some nasty bandages ... What are you, poor mean-like mortal who talks in the style of a sovereign?

Stripped of their youthful beauty, the courtesan and the Queen were ridiculous, reduced to parodies of their lost magnificence.

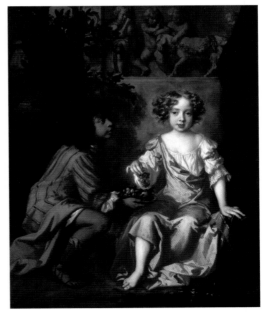

above left:

Louise de Kéroualle, with her son,
Charles Lennox (1672–1723)
(Henri Gascar, c1675)

above right:

Charlotte FitzRoy (1664–1718)
(Peter Lely, c1672)

Louise's royal son became Duke of
Richmond in 1675, aged three, the same
year that Barbara Villiers's eldest sons,
Charles and Henry, were created Dukes
of Southampton and Grafton, respectively;
Barbara's youngest, George, was made
Duke of Northumberland in 1683.
Barbara's eldest daughter, Anne, married
the Earl of Sussex, and Charlotte married
Sir Edward Lee, who received the Earldom
of Lichfield as a wedding present.

However, beauty is a resilient force, and its dominion can be passed on in the genes. Barbara, and her rivals Louise de Kéroualle and Nell Gwyn, left rich legacies for their children and descendants. All five of their illegitimate royal sons who survived to adulthood were given dukedoms, with all of the estates, wealth and influence that went with them; all made good marriages with daughters of the established nobility. Not everyone approved. Evelyn wrote how Isabella Bennet, the 12-year-old daughter of the Earl of Arlington, 'the sweetest hopefullest and most beautiful child, and most virtuous too' was being 'sacrificed to a boy that had been rudely bred'. Henry, Duke of Grafton (Barbara's second son, the boy in question), later dispelled Evelyn's concerns, becoming a conscientious courtier and dying a heroic death in battle in 1690. Isabella, painted that year by Kneller as the first of the 'Hampton Court Beauties', would marry again – to the prominent politician Sir Thomas Hanmer – and would live into her 50s, still wearing 'a great high head-dress such as was in fashion fifteen years ago, and looks like a mad woman in it'.

Nell Gwyn's surviving son, Charles Beauclerk, Duke of St Albans, was married to another of Kneller's beauties, Diana de Vere, the daughter of the 21st and last Earl of Oxford. As George Savile, Marquess of Halifax, wrote in 1703:

The line of Vere, so long renowned in arms,
Concludes with lustre in St Alban's charms.
Her conquering eyes have made their race complete.
They rose in valour, and in beauty set.

Diana and Charles had nine sons and three daughters over the course of an apparently happy marriage that ended with the Duke's death in 1726.

One way or another, beauty endures. The beautiful revolution of the late 17th century survives in the bloodlines and fortunes of the descendants of Charles's mistresses and in the baroque art that decorates Hampton Court Palace and elsewhere. Most particularly, in an age when women themselves did not write prolifically about their own experiences, and left very few words to describe how *they* felt about beauty and being beautiful, it can be glimpsed in the portraits of Peter Lely and Godfrey Kneller. These portraits were, admittedly, created by men and subject to male ideals of beauty and virtue, yet they are also testament to the power and identity of women at Court during this period.

Women certainly took an interest in how they were presented by artists, recognising the impact of a portrait and the power of beauty. They realised, as Roy Strong has written, that 'to be a great beauty one has to be *seen* to be a great beauty'. Not only did women like Nell Gwyn and Barbara Villiers have their portraits painted regularly, but also these portraits were engraved, printed and circulated for wider consumption. Collecting portraits of 'illustrious ladies' became a popular pastime, and not just for dirty old men like Pepys; series of engraved prints often included women like Margaret Cavendish or Aphra Behn, famed for their learning rather than their beauty. Women took possession of this narrative and, on occasion, were able to direct their own lives and careers with a new-found freedom because of it. In radically improved economic circumstances, women outside Court basked in some of this reflected glory and shared in some of this success.

Beauty itself remains an eternally ambivalent concept. It is both an aesthetic experience and an instrument of ambition, a conduit to pleasure and a magnet for immorality. The pursuit of beauty is a quest to define the indefinable, to try to understand the mystical allure of perfect form or colour, or of a bewitching smile. It is also the cynical manipulation of sexual attraction and the vainglorious advertisement of lust. The late Stuart period saw an

Diana de Vere (1677–1723) ★

(Godfrey Kneller, c1691)
The mother of Diana de Vere, Duchess of St Albans, was Diana Kirke, who had first sat for Lely as the mistress (but later wife) of the Earl of Oxford. Diana de Vere served the crown successively as Maid of Honour, Lady of the Bedchamber and ultimately Lady of the Stole to Queen Caroline: from mistress to principal courtier in one generation.

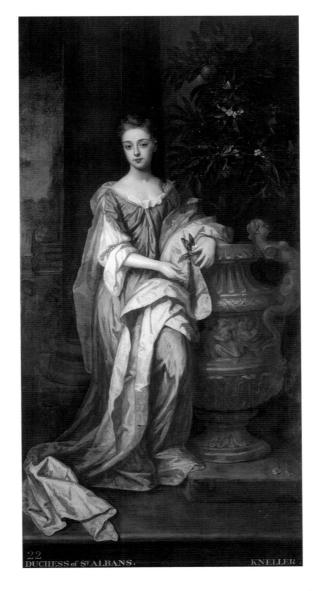

22
DUCHESS of St ALBANS. KNELLER.

engagement with these paradoxes, and the evolution of a modern perception that treats sentiments, tastes and passions as counterbalances to the dictatorship of reason.

Over the next three hundred years, beauty would be written and argued about, defined and categorised. Beauty would be defended for its sublime magnificence, embraced for its sensuality and dismissed for its cultural relativism. Beauty is still, today, worshipped, coveted, feared and despised. It will always be so. We are still not sure what it is, or what it is for.

Further Reading

This is a short list of some of the most helpful and recent books on the subjects explored in *Beauty, Sex and Power*. Most will have their own bibliographies that will take the enthusiastic reader further into the dissolute world of the late 17th and early 18th century. Dates given below are the original date of publication, but many of these books are available in modern editions; some are available as electronic versions on the Web.

Contemporary accounts and histories
Gilbert Burnet, *History of My Own Time* (1724 and 1734)
Patricia Crawford and Laura Gowing (eds), *Women's Worlds in Seventeenth-Century England: A Sourcebook* (2000)
George deForest Lord (ed.), *Poems on Affairs of State: Augustan Satirical Verse 1660–1714* (1963–75)
Roger de Piles, *The Art of Painting* (1706), English edition
John Evelyn, *Diary* (1818)
Mary Evelyn, *Mundus Muliebris, or the Ladies Dressing-Room Unlock'd, and her Toilette Spread* (1690)
Anthony Hamilton, *The Memoirs of Count De Grammont* (1713)
Christopher Morris (ed.), *The Journeys of Celia Fiennes, 1685–1712* (1982) illustrated edition
Samuel Pepys, *Diary* (1825)
Jonathan Richardson, *Two Treatises* (1719)
Philip Stanhope, Earl of Chesterfield, *Correspondence*, printed with *A Defence of Barbara Villiers* (by Elza de Locre) (1929)
Richard Steele, *The Tatler* (1709–11)
Richard Steele and Joseph Addison, *The Spectator* (1711–14)
J. Stevens Cox (ed.), *Hair and Beauty Secrets of the 17th century* (1971)
Horace Walpole, *Anecdotes of Painting* (1762–71)

Biographies of Court beauties and mistresses
Rosemary Baird, *Mistress of the House* (2003)
Charles Beauclerk, *Nell Gwyn* (2005)
Elizabeth Hamilton, *The Illustrious Lady: a Biography of Barbara Villiers* (1980)
Frances Harris, *Transformations of Love* (2002)
Brian Masters, *The Mistresses of Charles II* (1979)
Lewis Melville, *The Windsor Beauties* (1928)
Derek Wilson, *All the King's Women* (2003)
Oxford Dictionary of National Biography

Art and artists
Ronald Beckett, *Lely* (1951)
C.H. Collins-Baker, *Lely & Kneller* (1922)
Christopher Lloyd, *The Royal Collection* (1992)
Catherine MacLeod and Julia Marciari Alexander (eds), *Painted Ladies* (2001)
Catherine MacLeod and Julia Marciari Alexander (eds), *Politics, Representation and Transgression at the Court of Charles II* (2007)
Oliver Millar, *Tudor, Stuart and Early Georgian Pictures in the Collection of Her Majesty The Queen* (1963)
Oliver Millar, *Sir Peter Lely* (1978)
Elizabeth Prettejohn, *Beauty and Art* (2005)
Aileen Ribeiro, *Facing Beauty* (2011)
J. Douglas Stewart, *Kneller* (1971)
J. Douglas Stewart, *Kneller and the English Baroque* (1983)
J. Douglas Stewart and Herman W. Liebert (eds), *English Portraits of the Late 17th and Early 18th Centuries* (1973)
Roy Strong, *The Masque of Beauty* (1972)

General history and the Court
Robert Bucholz, *The Augustan Court* (1993)
Clarissa Campbell Orr, *Queenship in Britain* (2002)
Eveline Cruikshanks, *The Stuart Courts* (2000)
Graham Greene, *Lord Rochester's Monkey* (1976)
Edward Gregg, *Queen Anne* (1980)
Frances Harris, 'The Honourable Sisterhood', *British Library Journal*, XIX (1993)
Tim Harris, *Restoration: Charles II and his Kingdoms* (2005)
Ronald Hutton, *Charles II* (1989)
John Miller, *James II* (1978)
Aileen Ribeiro, *Fashion and Fiction: Dress in Art and Literature in Stuart England* (2006)
Jenny Uglow, *A Gambling Man: Charles II and the Restoration* (2009)
Maureen Waller, *Ungrateful Daughters* (2002)

Stuart England: the world outside Court
Richard Adair, *Courtship, Illegitimacy and Marriage in Early Modern England* (1996)
Peter Earle, 'The female labour market in London in the late 17th and early 18th centuries', *Economic History Review*, 2nd series, XLII (1989)
Ann Kussmaul, *A General View of the Rural Economy of England, 1538–1840* (1990)
Liza Picard, *Restoration London* (1998)
Mary Prior (ed.), *Women in English Society, 1500–1800* (1985)
David Souden, 'Migrants and the population structure of later seventeenth-century provincial cities and market towns', in Peter Clark (ed.), *The Transformation of English Provincial Towns 1600–1800* (1984)
David Souden and David Starkey, *This Land of England* (1985)
Claire Tomalin, *Pepys: The Unequalled Self* (2002)
Keith Wrightson, *Earthly Necessities: Economic Lives in Early Modern Britain, 1470–1750* (2002)
E.A. Wrigley and R.S. Schofield, *The Population History of England, 1541–1871: A Reconstruction* (1985), revised edition